2007 RENWICK CRAFT INVITATIONAL
from the ground up

2007 RENWICK CRAFT INVITATIONAL
from the ground up

written by

Jane Milosch and Susanne Frantz

foreword by

Lloyd Herman

Renwick Gallery of the
Smithsonian American Art Museum
Washington, D.C.

From the Ground Up: Renwick Craft Invitational 2007
By Jane Milosch and Susanne Frantz with foreword by Lloyd Herman

Published in conjunction with the exhibition of the same name, on view at the Renwick Gallery of the Smithsonian American Art Museum, Washington, D.C., March 9–July 22, 2007.

Chief of Publications: Theresa J. Slowik
Editor: M. Theresa Blackinton
Designer: Jessica L. Hawkins
Art Director: Karen Siatras

Smithsonian American Art Museum
Renwick Gallery

The Renwick Gallery of the Smithsonian American Art Museum collects, exhibits, studies, and preserves American crafts and decorative arts from the nineteenth to twenty-first centuries. Housed in a historic architectural landmark on Pennsylvania Avenue at 17th Street NW, the Renwick features one-of-a-kind pieces created from clay, fiber, glass, metal, and wood.

The Smithsonian American Art Museum is home to one of the largest collections of American art in the world. Its holdings—more than 41,000 works—tell the story of America through the visual arts and represent the most inclusive collection of American art in any museum today. It is the nation's first federal art collection, predating the 1846 founding of the Smithsonian Institution. The museum celebrates the exceptional creativity of the nation's artists whose insights into history, society, and the individual reveal the essence of the American experience.

For more information or a catalogue of publications, write: Office of Publications, Smithsonian American Art Museum, MRC 970, PO Box 37012, Washington, DC 20013-7012

Visit the museum's Web site at AmericanArt.si.edu

Cover: Beth Cavener Stichter, *Olympia* (detail), 2006, stoneware, porcelain slip, polyester, and mixed media, 24¾ × 44½ × 31½ in., Collection of Christine Rémy

Back Cover: Paula Bartron, *Black Cylinder*, 2006, blown and sand-cast glass with glass powders, 15¾ x 15⅜ in. diam., Collection of the artist

Frontispiece: Paula Bartron, *Red Cylinder* (detail), 2004, blown and sand-cast glass with glass powders, 11 × 9⅞ in., Collection of the artist

Facing Dedication: Beth Lipman, *Stilleven (after Willem Claesz Heda)* (detail), 2005, hand-sculpted, blown, kiln-formed, lampworked glass, oak, and paint, 58 × 47½ × 27½ in., Collection of Nancy and Philip Kotler

Facing Epigraph: Jocelyn Châteauvert, *Migration* (detail), 2006, abaca and mixed media, 60 × 17 × 13 in., Collection of the artist

Library of Congress Cataloging-in-Publication Data

Renwick Craft Invitational (Exhibition) (3rd : 2007 : Washington, D.C.)
From the ground up: Renwick Craft Invitational 2007 / Jane Milosch and Susanne Frantz; foreword by Lloyd Herman.
 p. cm.
Published in conjunction with an exhibition held at the Renwick Gallery, Smithsonian American Art Museum, Washington, D.C., 2007.
ISBN-13: 978-0-9790678-1-5 (pbk.: alk. paper)
ISBN-10: 0-9790678-1-2 (pbk.: alk. paper)
1. Decorative arts–United States–History–20th century–Exhibitions. 2. Art glass–United States–History–20th century–Exhibitions. 3. Paper art–United States–History–20th century–Exhibitions. 4. Ceramic art–United States–History–20th century–Exhibitions. I. Milosch, Jane. II. Frantz, Susanne K. III. Renwick Gallery. IV. Title.

NK808.R45 2007
748.20973'074753–dc22

2006038790

contents

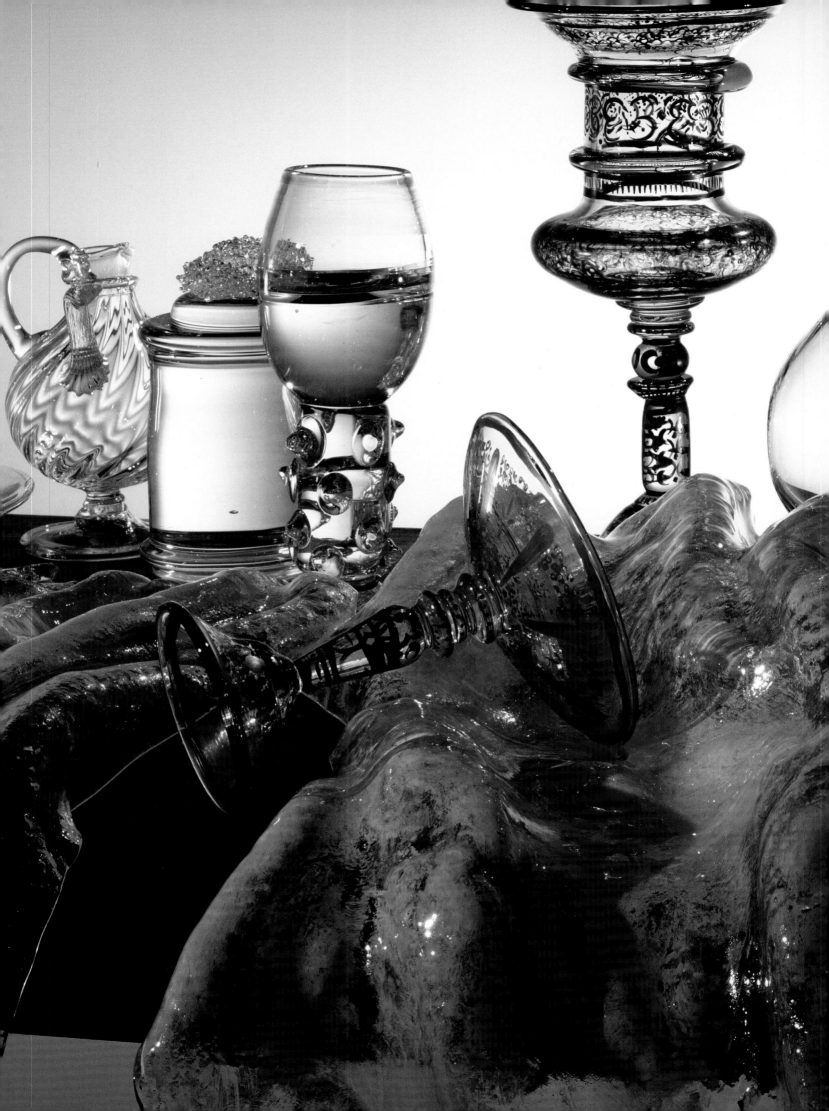

dedication

The *Renwick Craft Invitational 2007* announces a new era in the exhibition program of this premier craft museum's history. A major gift from the Ryna and Melvin Cohen Family Foundation in 2005 now provides stable support for this biennial exhibition. The Foundation's landmark gift means that the Renwick Gallery will continue to feature America's most talented craft artists far into the future. We are especially happy that the Cohens' generosity allows us to publish a catalogue for each Invitational, creating an enduring record for this series.

Biennial exhibitions have a strong tradition in American museums. The Carnegie International series, founded in Pittsburgh in 1896, was for some time a biennial. Other museums picked up the idea in the twentieth century, including the Whitney Museum in New York and the Corcoran Museum in Washington. Now the highly creative field of craft has its own biennial, committed to the finest accomplishments of artists who choose to work in clay, wood, metal, fiber, and glass.

This handsome volume serves as a record of the third Renwick biennial. The generous gifts of Shelby and Frederick Gans and Eleanor and Sam Rosenfeld made possible the first two Invitationals in 2000 and 2002. We are grateful for their vision in helping us begin the Invitational tradition. We dedicate this volume to Ryna and Melvin Cohen and their family, with gratitude for their generosity. All of these patrons have shown great commitment to the Smithsonian and to America's artists.

ELIZABETH BROUN
The Margaret and Terry Stent Director
Smithsonian American Art Museum

foreword

When we opened the Renwick Gallery in 1972, it was to showcase the creative work of American craftsmen and designers, past and present, in temporary exhibitions. But because this was a new child in the Smithsonian Institution's family, we concentrated on established makers and rarely included craftspeople in their early or middle careers except in broader survey exhibitions—usually organized by other institutions. There were at that time a number of national competitions for craftspeople of all disciplines. Although such venues afforded some visibility for emerging artists, the exhibits remained local and participants rarely received much publicity. It was only in 1975 when the Renwick sponsored a national competition for craftspeople making at least ten of the same original design—which resulted in the nationally touring *Craft Multiples* exhibition—that the Gallery itself showcased quality work by lesser-known talents. That also marked the start of the Renwick's deliberate acquisition of new work for the national craft collection.

It was important, then, when my second successor running the Gallery, Kenneth Trapp, launched the *Renwick Craft Invitational* in 2000. This year—twenty years after my retirement—I am honored to be invited back to the Gallery that I shepherded for its first fifteen years as a selector of artists for this third Invitational, along with my esteemed colleagues and friends, Susanne Frantz and Jane Milosch. We searched our files, exhibition catalogs, and memory banks; then each of us nominated three to five artists who had developed a body of

work large enough to evaluate—but who were not yet widely known. Through phone conversations and emails we compared photographs of recent objects by our nominees. These were culled from our files or from the artists' or their galleries' Web sites (how different from our complete reliance on color slides thirty-five years ago!). We finally reduced the numbers to those whose work is published here—Paula Bartron, Beth Lipman, Beth Cavener Stichter, and Jocelyn Châteauvert.

Bartron's cast, blown, and fused objects—with their raw sand surfaces and relationship to the primitive—challenge our conceptions of glass and its properties. Lipman's glittering three-dimensional replicas of Renaissance still-life paintings remind us that artists today in all disciplines are likely to have a grounding in art history. Lipman provides a glass "lens" through which to evaluate the accomplishments of artists past—in both painting and glass. Stichter extends a long tradition of figurative ceramic sculpture, and celebrates the tactility of clay in her energetic and lively animals. And Châteauvert's choice of paper as a medium addresses the changing dimension of craft today. She takes a material identified with the fine arts and exploits its lightness and translucence to create elegant jewelry and luminous objects. With the celebration of the Renwick Gallery's thirty-fifth anniversary in 2007, this exhibition series is now a biennial presentation, thanks to the generosity of the Ryna and Melvin Cohen Family Foundation. Their support assures that every two years the work of craft artists deserving of greater attention will have the spotlight at the Renwick.

LLOYD E. HERMAN
Director Emeritus, Renwick Gallery

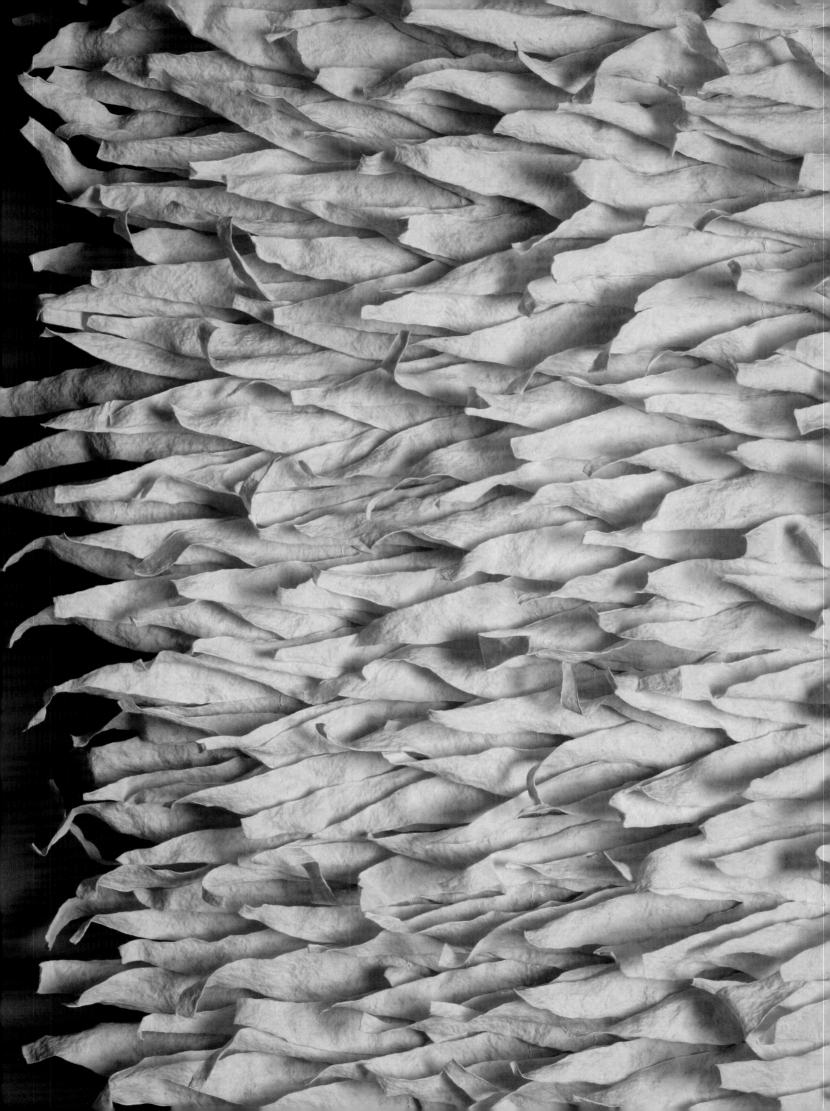

Architects, sculptors, painters, we all must return to the crafts!…There is no essential difference between the artist and the craftsman. The artist is an exalted craftsman. In rare moments of inspiration, transcending the consciousness of his will, the grace of heaven may cause his work to blossom into art. But proficiency in craft is essential to every artist. Therein lies the prime source of creative imagination.

WALTER GROPIUS
Program of the Staatliche Bauhaus in Weimar
1919

introduction

From the Ground Up: Renwick Craft Invitational 2007 features nearly fifty works by four artists—Paula Bartron, Beth Lipman, Beth Cavener Stichter, and Jocelyn Châteauvert—whose imagination is matched by their consummate craftsmanship. While grounded in the rudiments of their craft, they are also innovative masters of their media. All of them work in traditional craft media—clay, glass, and fiber—with an awareness of both the artistic and decorative traditions connected to the material. Each artist's technical virtuosity with her material is employed to give sculptural form to her concepts.

Testing the boundaries of materials and process was imperative for these artists to discover the expressive potential of their material in the service of artistic vision. Since the 1950s, this approach to making art has been at the heart of the American studio craft movement, so it is fitting that the book's epigraph from Gropius also appears in the memoirs of several first-generation American studio craft artists.[1] When Gropius issued his manifesto for the founding of the Bauhaus, an art school that flourished in Weimar Germany, the pedagogical model he advocated for students was a program of study grounded in workshops with both artists and master craftsmen. The impact of his teachings found fertile ground in post-World War II America, when many art departments at liberal arts colleges and universities began to offer courses in ceramics, fiber, glass, and metalsmithing alongside painting and sculpture classes. The four artists in this exhibition expanded and developed their work through studies with master craftsmen within and also beyond the university.

Each of the artists selected for the *Renwick Craft Invitational 2007* has a significant body of mature work; they have developed individual visions that have been refined through years of focused work. Bartron creates glass sculptures—cylinder vases, boxes, basins—with an emphasis on minimal geometric forms, fueled by her experimentation with glass blown into and cast in sand molds. Châteauvert uses handmade paper and metalsmithing techniques to create tactile jewelry, lighting designs, and installations, which are inspired by the myriad ways handmade paper has been used in Asia. Lipman translates seventeenth- and eighteenth-century still-life paintings into three-dimensional blown and lampworked glass sculpture which takes its inspiration from—even as it slyly rejects—the Venetian glassblowing tradition. Informed by her study of sculptors such as Manzù, Rodin, and Italian masters of the baroque and mannerist periods, Stichter creates clay sculptures that focus on human psychology articulated through animal forms. These artists start from the ground up, using the elements of the earth—clay, sand, fiber—as the catalysts and vehicles for their imagination. Their work is an amalgamation of material, process, and ideas.

Mystery is at the heart of craft. The excitement begins when these artists grab hold of the jugular vein of their chosen medium—to feel the power and push it for all it's worth, and to draw out its expressive potential. This process entails yielding to, questioning, and challenging the characteristics of their materials; only then does the work lead to results that are masterful and unexpected. Bartron, Châteauvert, Lipman,

and Stichter willingly relinquish some of their control to the unknown, specifically when their materials are in a state of flux—in the kiln, furnace, or vat.

An element of the unknown is often what attracts these artists to their respective media—each has chosen a material that continues to inspire her imagination. Châteauvert sculpts her handmade paper sheets while they are wet and malleable to achieve a desired form; but how the fibers will finally align, once they are dry, is beyond her control, so she may rework the paper to enhance or de-emphasize effects that occurred in the drying process. When Bartron creates her glass forms in sand molds, she uses oxides in the glass to achieve a specific color, but she cannot predetermine how much encrustation will adhere and remain on the surface. After the work has cooled, she reworks her glass "bars" by cutting, grinding, and fusing them together to achieve a desired form, with the result depending on textured surface, which is beyond her control. Some craft artists are drawn into the mystique of the material and the process to the extent that it overshadows the work. When this happens, the work remains personal; it does not advance to something universal, articulated through an individual vision. The four artists exhibited in the *Renwick Craft Invitational 2007* have moved beyond the material and process to transform the elements of the earth—clay, sand, fiber—into works of art.

The way these artists approach their chosen material is informed by their aesthetic preferences and reveals a connection to the decorative arts tradition. All make objects to be contemplated on a sensory level.

Châteauvert makes refined, organic objects for use. Some of Bartron's glass vessels negate the possibility of use through rough, painterly surfaces. Stichter's animals are posed and painted in a decorative manner. The narrative qualities and scale of her animals reach a mythical level, not unlike the animal forms that ornament both classical and romanesque architecture. Lipman's tour-de-force banquet scene in glass gives us a heightened awareness of the meaning and significance of craft, ritual, and decoration. Her elaborate table laden with the remains of an opulent feast—lush, dripping detail which ornaments the whole scene—both celebrates excess and mourns it. The tableau seems overwhelming; but the glass is so beautiful that it draws us back and back again. The banquet becomes timeless and takes on an excitement that calls us to an event—one that happened, is happening, and will happen. Where are we in the process?

With this exhibition you are invited to a feast of sensory experience, with each entrée prepared from the ground up.

JANE MILOSCH
Curator, Renwick Gallery

[1] In a lecture entitled "Vision and Voice: The Nanette L. Laitman Documentation Project," which was presented at SOFA New York on June 2, 2005, Mija Riedel noted that in her review of the papers of major studio craft artists she came across numerous quotes by Walter Gropius, including the quote used as this book's epigraph. The Nanette L. Laitman Documentation Project for Craft and Decorative Arts is a five-year project to produce 100 oral interviews and to collect the papers of prominent artists in the United States working in clay, wood, fiber, metal, and glass. This project is directed by Liza Kirwin, curator of manuscripts at the Archives of American Art, Smithsonian Institution.

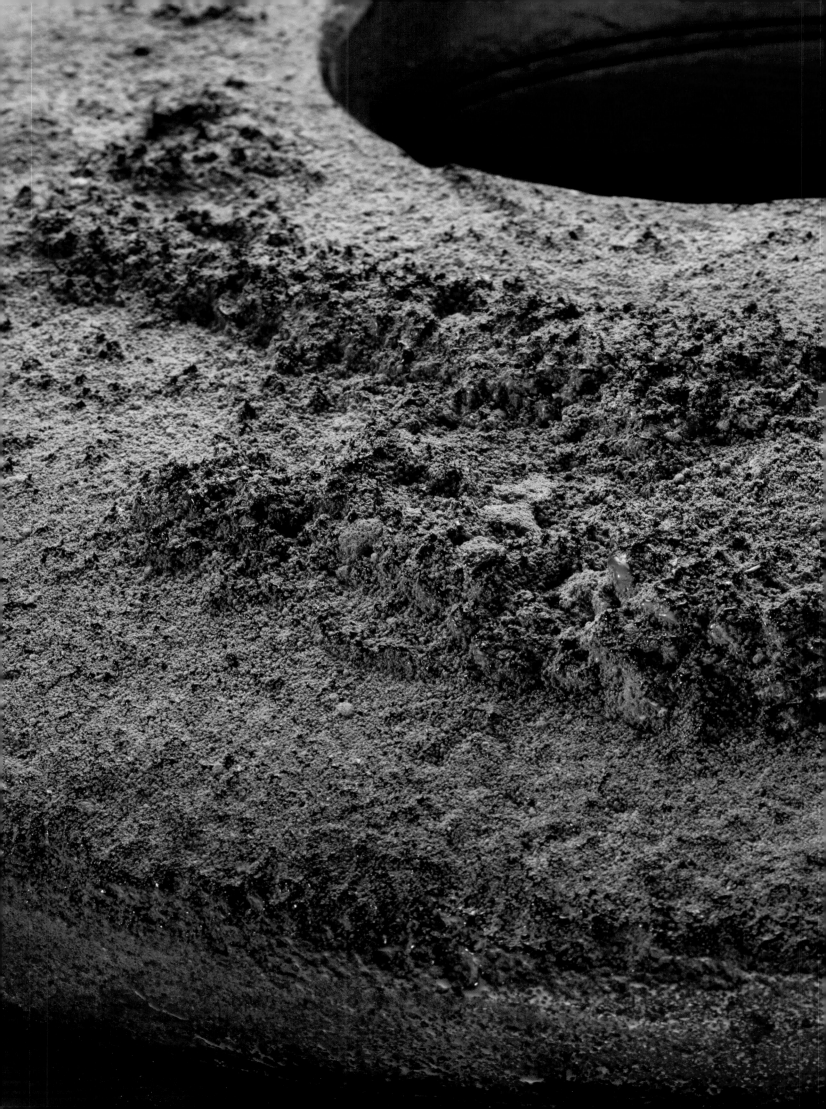

paula bartron

Take two comparatively talented and accomplished artists: What makes one "hot" and one not? In the American glass world, as in other arenas of art, pure talent may play a secondary role. To ensure public recognition, an artist must expend considerable effort: find a committed and reputable gallery, meet with collectors and curators at the commercial expositions, and lobby for inclusion in prominent exhibitions and publications. What if an artist doesn't click with the right people, or have a partner who handles business matters, or quite simply, prefers not to engage in the act of self-promotion? Such factors explain, at least in part, why there are so many conspicuously under-recognized artists of merit working in all media.

◁◁

Blue Disks (detail), 1997,
sand-cast glass, 28 disks,
each 2 ¼ × between
15 ½ and 15 ¾ in. diam.
Collection of the artist

By all rights, Paula Bartron should be venerated as one of the pre-eminent American artists using glass. She was among this country's early studio glass practitioners and one of a very few female glassblowers in the early 1970s. Bartron studied for her master's degree at the University of California, Berkeley, at a time when the crafts were part of the School of Environmental Design rather than the fine art department. During her student years she studied under Peter Voulkos and Ron Nagle in ceramics and Marvin Lipofsky in glass, her area of specialization. Like other artists hoping to achieve greater technical expertise in glass—still a very young field in the United States—Bartron turned to Europe after graduation. In 1972 she attended one of the seminal events in studio glass history: the symposium *Glas Heute: Kunst oder Handwerk?* (*Glass Today: Art or Craft?*) organized by the Museum Bellerive in Zurich, Switzerland. The gathering was the first opportunity for a large number of European and American artists and designers to come together on the topic of studio glass. The next year Barton became one of the first Americans to study at the industrially-oriented glassmaking school in Orrefors, Sweden. She then spent ten months as an apprentice to Kaj Franck and Oiva Toikka at the Nuutajärvi glassworks in Finland, and Bartron cites this period of training with two giants of twentieth-century glass design as her pivotal educational experience. Like Richard Meitner, another American expatriate artist in glass, Bartron remained overseas to work independently and to teach. In 1975 she founded the studio glass program at Konstfack (University College of Arts, Crafts, and Design) in Stockholm and has remained on the faculty

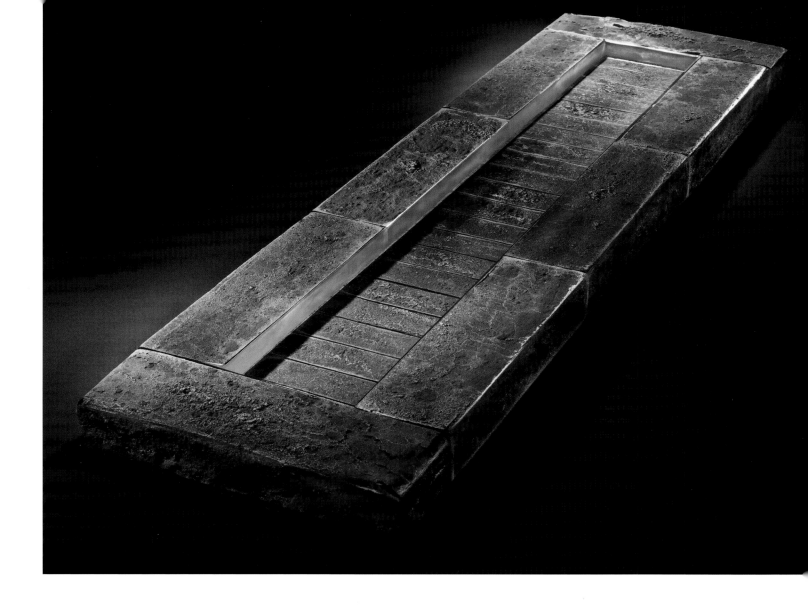

to this day. Over the years, respect for Paula Bartron has grown steadily in Europe and Japan, while her work is not adequately known or appreciated in her native country.

Every generation makes a material modern in its own way. Paula Bartron, and those of her peers who watched what was being done in other media, have done so for glass. In the late 1970s, Bartron's signature blown bottles with tree-shaped tooled stoppers were still very much tied to ceramics—in a playful pop-art, funk, and Scandinavian-folk mode. Outside of the craft circle, sculptors wishing to use glass at this time, including Robert Smithson and Larry Bell, were limited to

Long White Basin, 1998,
**sand-cast and fused glass,
2 ½ × 49 ½ × 14 in.
Collection of the artist**

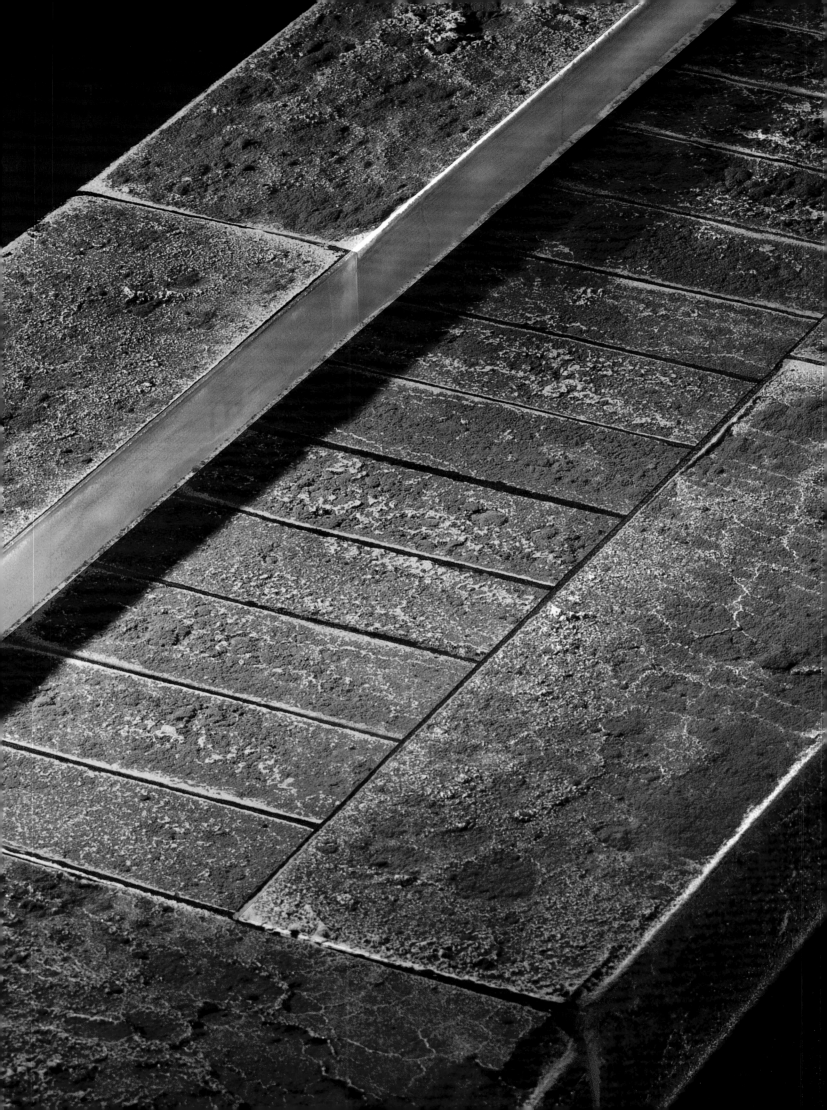

Long White Basin (detail),
1998, sand-cast and fused
glass, 2 ½ × 49 ½ × 14 in.
Collection of the artist

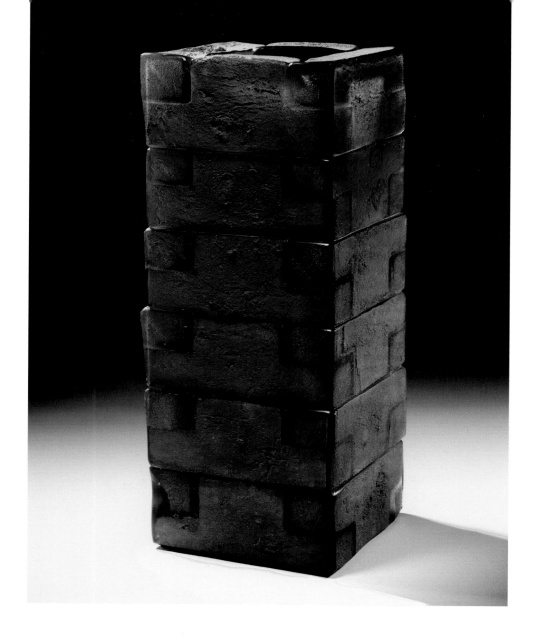

Tall Green Box, 1992,
sand-cast and fused glass,
20 ¾ × 8 × 8 in.
Collection of the artist

windowpanes, mirrors, and found objects. Only with the advancement of university-level studio glass programs did molten glass and trained craftspersons become available to such artists as Christopher Wilmarth and Lynda Benglis during the late 1970s and early 1980s. The influence of minimalism and post-minimalism becomes apparent in Bartron's work in the 1983 installation, *Lines and Planes*. She shaped and sandblasted multiple sheet-glass squares, giving them the appearance of dropped handkerchiefs or sheets of paper. Any suggestion of randomness was negated

when she aligned them on the floor in a strict grid. By 1988 the thin glass slips had grown into heavy plates and striped slabs, and then into open-work pallets of massive and rugged simplicity. It is tempting to compare Bartron's stacked, interlocking, and grated constructions with the wood, wire, brick, and concrete sculptures of Mary Miss and Jackie Winsor from the late 1960s and 1970s. Another precursor to her quiet embodiments of weight and compression are Thomas Bang's wood and glass floor constructions from slightly later. While Bartron is a longtime admirer of Winsor, she did not know the work of either Miss or Bang.

Black Box, 1992,
sand-cast and fused glass,
10 × 14 × 14 in.
Collection of the artist

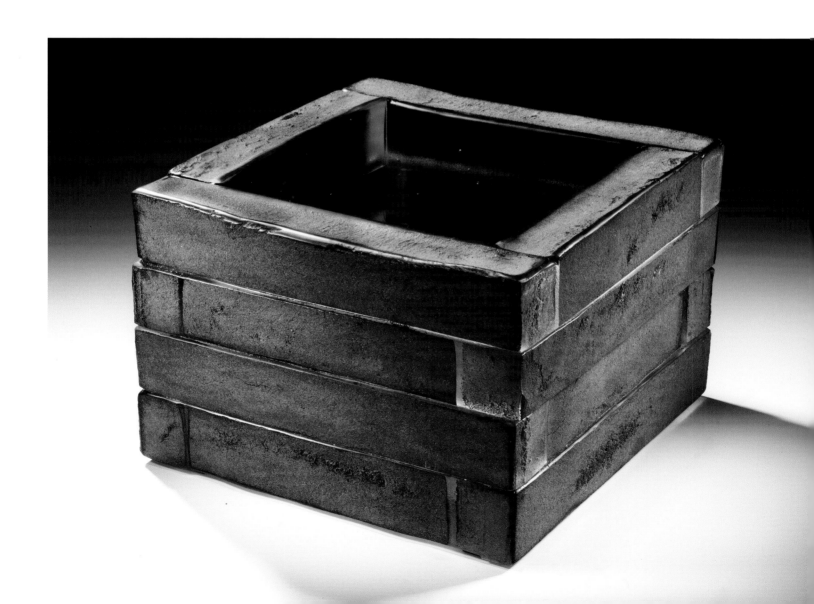

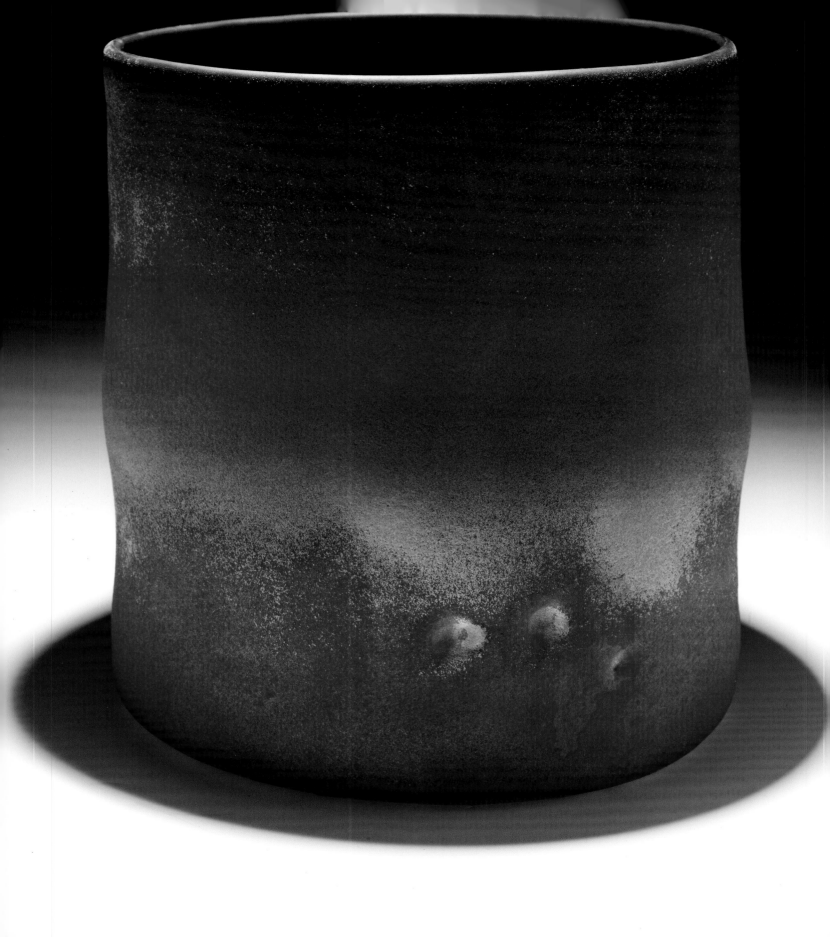

Bartron chose and stayed true to glass as the means to convey monumental, geometric formalism. She pours or blows it in molds made of compacted sand, which is left clinging to the glass in granular patches. Sometimes she fuses groups of cast bars together in a kiln and then re-heats that solid tablet until it "slumps" over a mold, adding a shallow curvature to the form. Bartron's sculptures are the abstracted kin of the functional: tables, basins, boxes, architectural masonry, and street pavers. Shaping matter in a sand mold is not a new idea. It entered the vocabulary of studio glass thanks to the work of Swedish artist Bertil Vallien. A sand mold is cheap, flexible, relatively easy to work with, accepts either blown or ladled molten glass, and because it is eventually broken away from the glass, can assume almost any form or size. Vallien's imagery revolves around intricate narratives. His thick transparent glass is critical to the suggestion of icy, watery, or weightless environments encapsulated for all eternity. The super-tactile surface produced when molten glass hits and fuses with the sand adds a blemished, organic element to what can be a chilly and aloof substance. The resulting encrustation becomes a tangible boundary between all manner of inner and outer worlds. When a viewer peers past the smooth top of one of Vallien's castings, the depths of his environments are revealed. This clarity exists only where the glass has been introduced into the mold but did not touch it, or through "windows" made by cutting or grinding away the rough skin. Unlike Vallien, who asks the viewer to explore what is trapped inside the material, Barton keeps the viewer's

◁

Red Cylinder, 2004,
blown and sand-cast glass
with glass powders,
11 × 9⅞ in. diam.
Collection of the artist

attention firmly trained on the surface—even within the deep, well-like cavities of the enclosed forms. For her wall of wheel-like *Blue Disks*, she turns the glossy faces to the wall, leaving the viewer to savor the cobalt that appears where the light penetrates the superficial crust and pops out at the thin edges like an encircling neon pinstripe.

At first glance, Bartron's disks or interlocking "brick" structures may look as if made from concrete or adobe. The same might be said for her "soft" cylinders, blown into the sand molds and then rendered almost opaque by glass powders sifted onto the still-hot exterior. The true brilliance of Bartron's exploitation of blown and cast glass becomes apparent as we grow more aware of her intent. Color and light seem to seep from between the blocks and illuminate the edges that are sawn clean. Like smells, tastes, and textures that are only appreciated once the other senses are deprived, so too the characteristics so valued in glass—luminosity, malleability, intense coloration or absolute "whiteness"—are amplified when the artist restricts our access to them. In the end, the tightly controlled radiance behind a textured sheath may be more satisfying than a roomful of glittering prisms.

As one looks at Barton's work—and even considers glass as a medium—it is crucial to keep in mind that there is no such thing as truth to the material. Although the eminent Victorian tastemaker John Ruskin held many bold and insightful opinions about glass, he erred when he asserted in *The Stones of Venice* (1851–1853) that glass must exhibit ductility and uncolored transparency (but not perfect clarity), and be left unmolested by

▷

Blue Disks (detail), 1997, sand-cast glass, 28 disks, each 2 ¼ × between 15 ½ and 15 ¾ in. diam. Collection of the artist

cutting lest it become "barbarous." Today's critics are equally short-sighted when they maintain that a single twentieth-century ideal (typified by Ruskin's beloved pellucidness and fluidity) is the only acceptable manifestation of glass—be it as tableware or sculpture. That school of thought stems from a cursory understanding of not only Bauhaus theory, but also the history of glass. Whether colorless or candy-hued; painfully thin or rock-like; enameled and engraved, or not: the aesthetics of glass—from ancient Rome, to Renaissance Venice, to functionalism and the sculpture that grew out of the studio glass movement—depend on historical and artistic context, not on an exclusive protocol for the material.

Pair of Gray Cylinders, **1999, blown and sand-cast glass with glass powders, 8 ½ × 9 in., 9 ¼ × 8 ⅝ in. Collection of the artist**

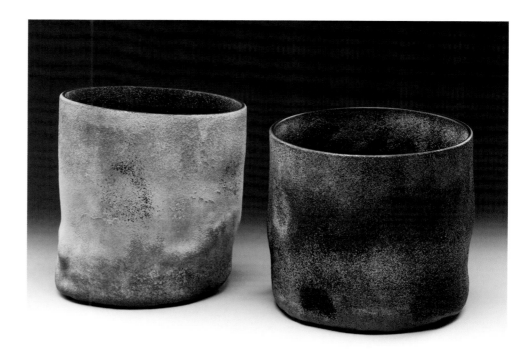

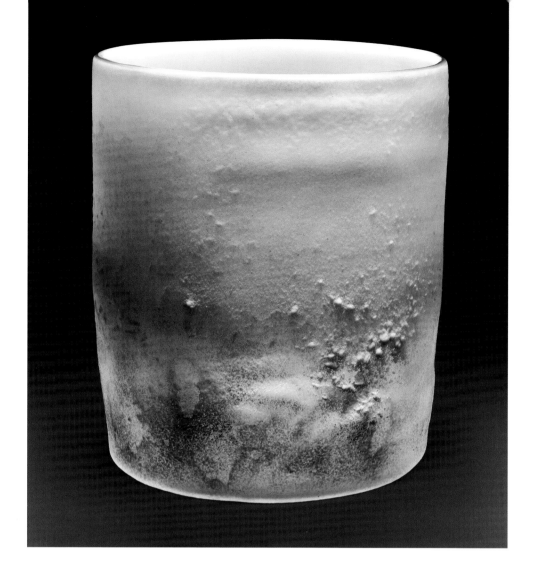

The under-the-radar character of Paula Bartron's career exemplifies the necessity for scholars and admirers of any artistic arena to dig deep and look beyond what is offered as the established canon of quality. Mature, serious, exceptional, and groundbreaking work may indeed be neglected or overlooked. Bartron's early relocation to Scandinavia affected her visibility in the United States, just as it surely influenced her visual thinking. Such spare and subtle yet immensely sensorial work challenges the viewer to reconsider any preconceptions regarding the nature of glass and the true, stately essence of its beauty. **SUSANNE FRANTZ**

White Cylinder, **2004–2005, blown and sand-cast glass with glass powders, 12 ¾ × 10 ¾ in. Collection of the artist**

beth lipman

The temptation to closely replicate an object in a non-native material is intriguing to almost anyone, especially artists. Who hasn't found Japanese plastic food fascinating? What art critic and philosopher Arthur Danto called "the transfiguration of the commonplace"—when the translation from one substance to another adds meaning and changes the status of an object—is an ancient tradition in the visual arts and can arguably be extended from the prehistoric to today. Obviously, this is a good thing—the history of art is based upon it; conversely, it can be parasitic and trite—a soul stealing rip-off. Artists in no medium are exempt from the temptation; however, those working in glass and clay seem especially susceptible.

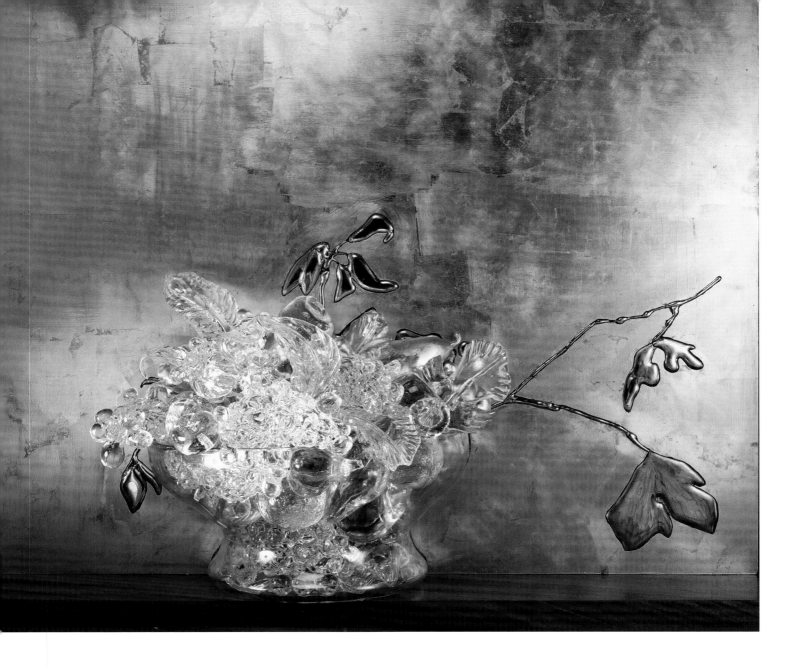

**Bancketje (Banquet) (detail),
2003, hand-sculpted, blown,
kiln-formed, and lamp-
worked glass with gold
paint, oak, oil, and mixed
media, 67 × 50 × 240 in.
Courtesy of Heller Gallery**

Take the idea of a glass flower: all kinds of aesthetic and meta-
phorical arguments may be offered for the execution of the fragile,
translucent, and perishable subject in glass. Exquisite examples exist
from throughout the centuries. With few exceptions (Émile Gallé's ex-
plicitly poetic depictions and Leopold and Rudolph Blaschka's exacting
scientific models from the turn of the twentieth century are the first
to come to mind), glass flora lay claim to no mission beyond the prov-
ocation of pleasure and, possibly, delighted incredulity. It would be a

lapse in judgment to mistake Beth Lipman's bountiful representations for such confection.

Working primarily in glass, Lipman re-creates still-life paintings from Renaissance and baroque Holland, Flanders, and Italy, as well as eighteenth- and nineteenth-century America. Her references range from almost literal expropriations of specific paintings to more relaxed interpretations evoking vaguely recognizable genres. Lipman also works in clay, and while her ceramics do sometimes refer directly to paintings, they do not always. Instead, they often remind us of Victorian and Edwardian material culture—both funereal and celebratory—as well as other intimate décor of the bourgeois home.

Lipman's contemporary work in glass incorporates a range of traditional methods including blowing, kiln-forming, and flamework. With hot glassworking necessarily lacking the immediacy of the artist's hand, Lipman relies on breath, heat, gravity, and shaping tools for the creation of her pieces. Clay, however, does not require much intervention between the material and the sculptor. As such, it harbors an emotional expressiveness potentially greater than glass. While the final gratification of clay is inherently delayed by a schedule of firings, Lipman stops short of the closure and veneer of glaze. Heating and reheating sometimes forces the pieces to disintegrate and break apart—what the artist describes as "letting the process of firing finish the work," a process with obvious similarities to the way in which she works with glass.

◁

Basket of Fruit (after Michelangelo Caravaggio), **2003, hand-sculpted, blown, and kiln-formed glass with gold leaf and gold luster, wood, and mixed media, 32 × 40 × 10 in. Private Collection**

At times Lipman works from still-life paintings to create renderings that are "real" in their three-dimensional physicality and scale. But these are not novelty tableaus of artworks brought to life. Lipman is quick to yank the rug of pictorial verisimilitude out from under the viewer. Her shapes attempt exact reproduction of neither the painted subject (an arrangement of fruit, for example) nor its edible counterpart. Additionally, in translating the scenes, Lipman drains them of their polychrome hues, recasting them instead in colorless, transparent glass with scattered gilding or in almost opaque black or milky white glass. The lack of definition caused by being able to look straight through the glass, says Lipman, inspires frustration and keeps anyone from "owning" the forms.

Physical details are washed away in the softness and blurred movement of what had been, possibly an instant before, truly molten and flowing. What is left after the substitution of materials and the stripping away of color and precise detail is the symbol of a symbol. The model, what had once been alive, was first turned by the painter into an imitation of life, and then Lipman boosted that representation to another level—still sufficiently close to reality to be familiar, but "off" enough to open the way to imagining a greater context.

In *Dead Birds (after Frans Cuyck van Myerop)*, game birds, still penned within a picture frame, have been loosely sculpted by stretching and nipping the glass. The dark glass obscures the details even more, but the representation is clear. Even the chalices and goblets in works such as

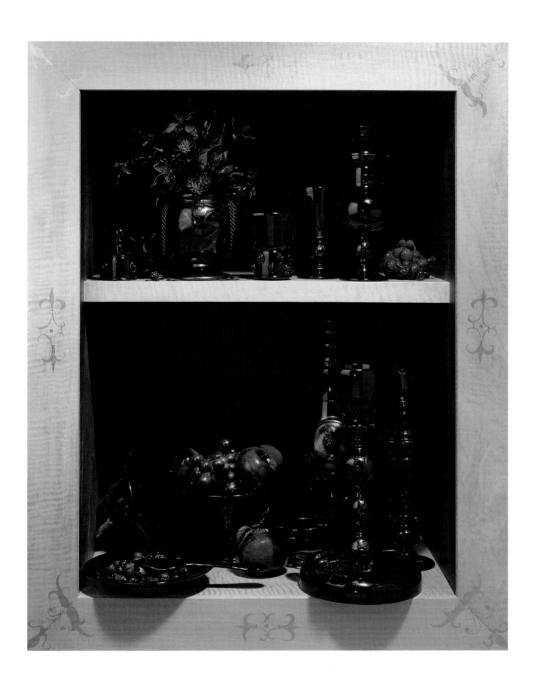

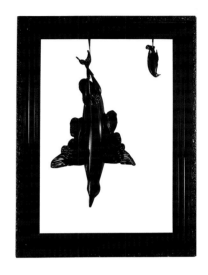

△
Dead Birds (after Frans Cuyck van Myerop), 2003, hand-sculpted glass, wood, oil, and mixed media, 43 ¾ × 31 ¾ × 3 ¼ in. Collection of Bill Fick and Kristen Hondros
◁◁ detail opposite

Cupboard Picture with Flowers, Fruit, and Goblets (after Flegel), 2002, hand-sculpted, blown, kiln-formed, and lampworked glass, wood veneer, acrylic, and mixed media, 35 ¾ × 27 ⅝ × 14 in. Collection of Sharon Karmazin

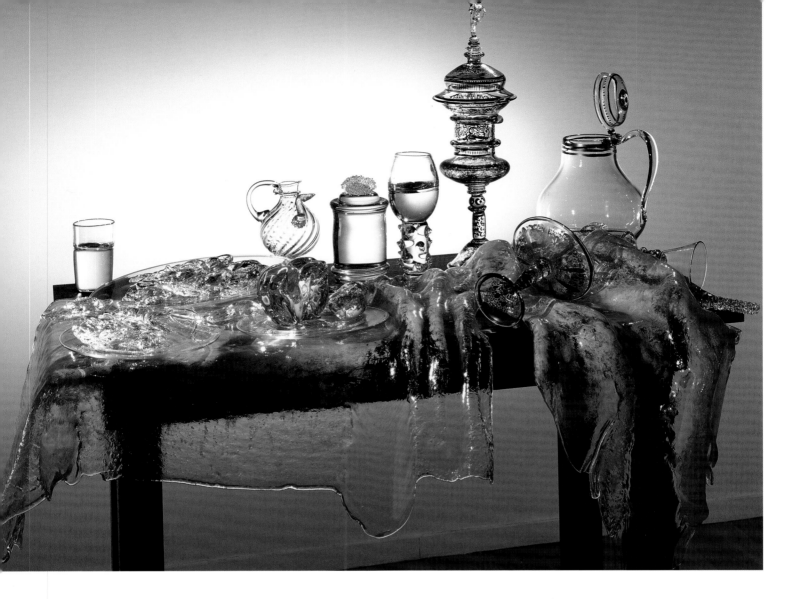

Stilleven (after Willem Claesz Heda), 2005, hand-sculpted, blown, kiln-formed, and lampworked glass, oak, and paint, 58 × 47 ½ × 27 ½ in. Collection of Nancy and Philip Kotler

▷

Tea Table II, 2005, hand-sculpted, blown, kiln-formed, and lampworked glass, gold lustre, and wood, 48 ½ × 34 in. diam. Collection of Anna and Joe Mendel, Montreal, Canada

Stilleven (after Willem Claesz Heda) and *Cupboard Picture with Flowers, Fruit, and Goblets (after Flegel)* are a pastiche of historically inspired components and proportions rather than faithful reproductions of period objects. Sometimes they are slightly distorted by further melting in a kiln.

Among the themes Lipman explores in her work, food and its many rituals loom large. During a college semester in Rome, she recalls her series of drawings of a torte, which she purchased, brought back to the studio, and then "drew and ate until I couldn't take another bite." It is no accident that Lipman uses the tableware media of choice—glass and ceramics—for her re-creations. As she has pointed out, in some artistic hierarchies the still life rests on one of the lowest rungs, just one step away from animal

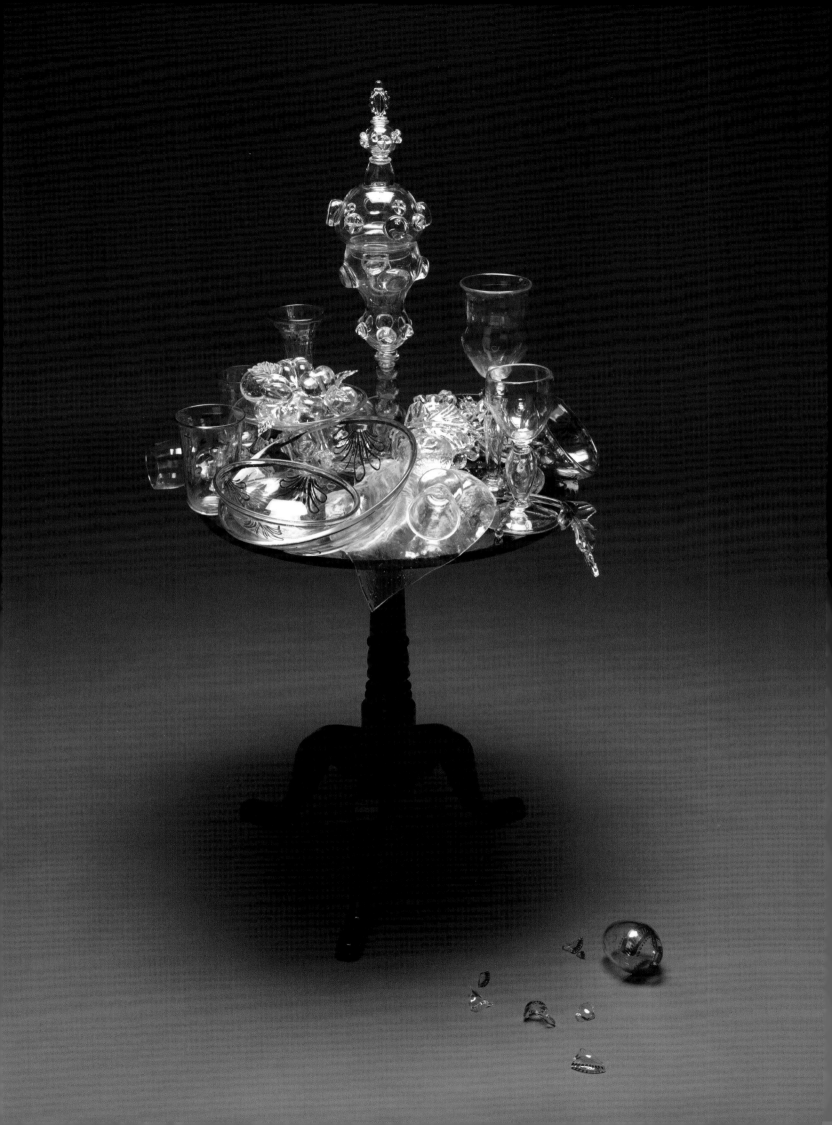

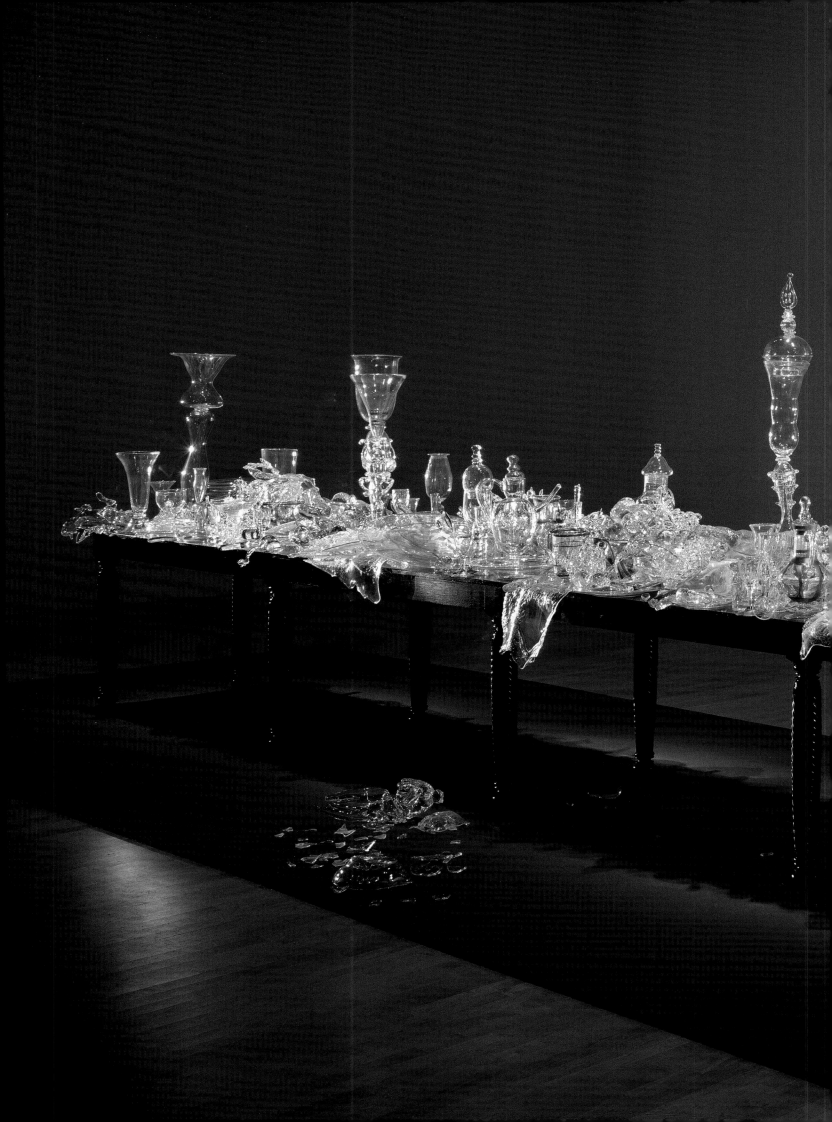

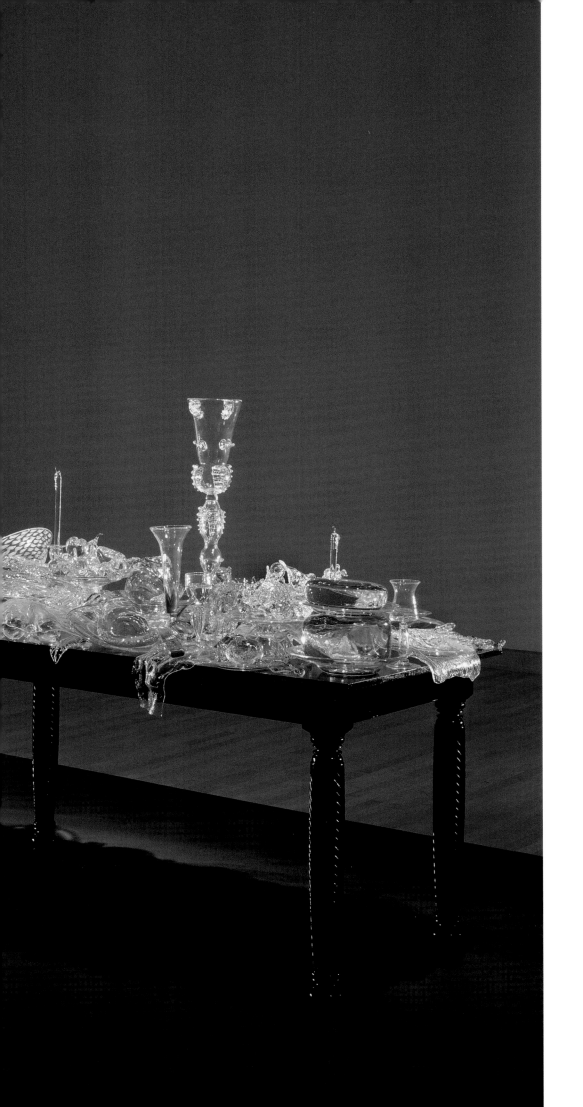

Bancketje (Banquet), 2003,
hand-sculpted, blown, kiln-
formed, and lampworked
glass with gold paint, oak,
oil, and mixed media,
67 × 50 × 240 in.
Courtesy of Heller Gallery

portraiture. The same can be said of the utilitarian decorative arts, specifically table garniture and the implements of dining. Her first still-life pieces and early Laid Table installations were of food, flowers, and feces (made of glass or sugar). "I long for minimalism and I long for excess," she says.

And excess is what she depicts in her *Bancketje*, a blurry rendering of the aftermath of a ferocious feast, containing more than four hundred components. This work, like most of her works, is entrenched in the still-life tradition. Abundance, sensuousness, fecundity, decadence, sacrifice, decay, and mortality are all rolled into one scene showing the wreckage of gluttony. While the details are engaging, the use of transparent glass and a lack of specificity in each object demand that the piece be considered in its totality, not in its minutiae.

Lipman's *Bancketje* may also be considered in parallel to the social commentary of Judy Chicago's sculpture *The Dinner Party* (1979). In Chicago's installation, the banquet table and its individual place settings make specific reference to female iconography, feminism, and the unacknowledged history of women. The fabrication process of the piece—communal feminine handwork—also made pointed references to gender roles in labor and the status of the crafts. But while Chicago presents a set table, as yet untouched, Lipman shows a table in the after hours of a feast—food half-eaten, glasses knocked over, dishes broken on the floor. And although Lipman's work is not overtly political, one still wonders: Who prepared and served the meal? Who trashed the setting and who cleans it up?

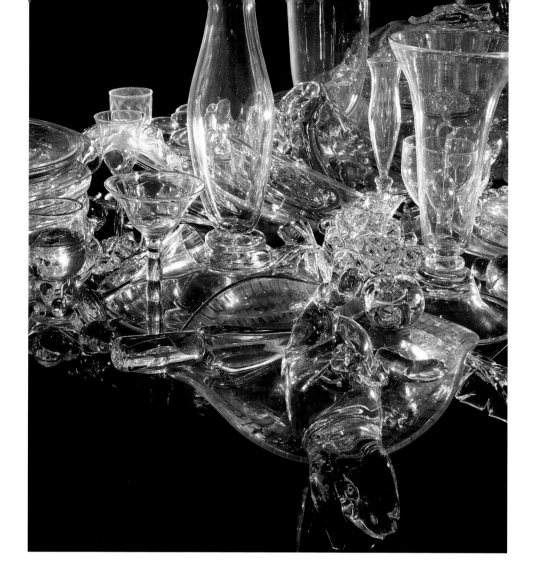

Bancketje also provides an opportunity to explore the process and idea of glassmaking, which Lipman studied at Tyler School of Arts at Temple University. While the possession of manual skill remains—astonishingly—a scarlet letter in the ranks of some artists, dealers, and collectors, Lipman doesn't mince around the fact that her technique can be as good or as poor as she chooses. No one requires a sculptor to make any or all of a piece with his or her own hands, but for certain work and for certain materials—like glass—the experience with and ensuing technical knowledge of a material can be critical. Mechanical choices are included in the make-or-break set of decisions dependent on the accumulated experience of the artist. Relying solely on the

Bancketje (Banquet) (detail), 2003, hand-sculpted, blown, kiln-formed, and lamp-worked glass with gold paint, oak, oil, and mixed media, 67 × 50 × 240 in. Courtesy of Heller Gallery

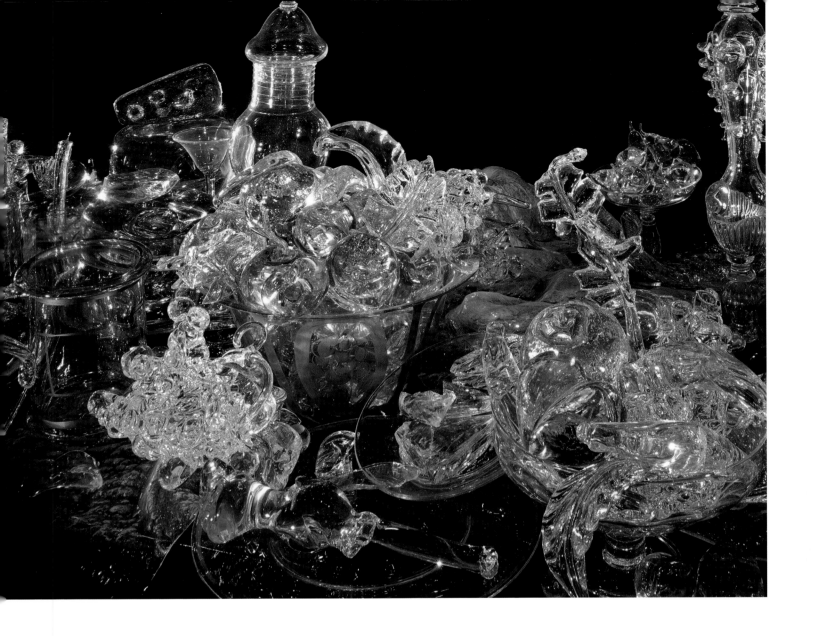

Bancketje (Banquet) (detail), 2003, hand-sculpted, blown, kiln-formed, and lamp-worked glass with gold paint, oak, oil, and mixed media, 67 × 50 × 240 in. Courtesy of Heller Gallery

recommendations of a "gaffer" (glassblower) does not necessarily diminish a work and may even add to it, but will always change it in some way. In creating the grandiose *Bancketje*, Lipman employed the help of others for the first time, collaborating with a team of fifteen glassmakers at the Creative Glass Center of America (CGCA).

What might be more contentious to worshipful adherents of classic Italian glassblowing technique is the fact that some of the components are assembled with adhesive. Those educated in the arts during the late 1960s and early 1970s will recall that while it was acceptable to stick things

together in various ways in sculpture class, it was sacrilege in ceramics. Not long after that, standards changed for clay sculpture, but glue lingers as the anathema of glass. Oh, how we agonized at the Corning Museum of Glass over the way Ettore Sottsass's iconic pieces for the Memphis Milano firm were put together. Even more disconcerting was the discovery that an early modern masterpiece of glass art, Gallé's 1903 *Dragonfly Coupe* (another vessel), was very likely originally assembled with some kind of adhesive! Lipman's own iconoclastic and ambivalent view of craftsmanship is confirmed by her recent experience as a visiting artist at a glassblowing studio: "[the hot shop manager] kept coming over and critiquing my technique; it eventually made me have to regroup, get fresh air, and completely abuse the material."

In her most recent efforts, Lipman is returning the still life to two-dimensionality and elusive unattainablity by photographing, then destroying, the glass and ceramic arrangements. Lipman is a youthful representative of artists who are highly trained in manual skill and devoted to hands-on fabrication, but who are not lashed to a rigid, narrow definition of the appropriate use of those resources. Material, technique, and attitude are subject to change. Her work, like Chicago's, is a splendid hybrid with one hand in craft and the other in contemporary art. It is a phenomenon that should be celebrated, even as it continues to elude proper christening. **SUSANNE FRANTZ**

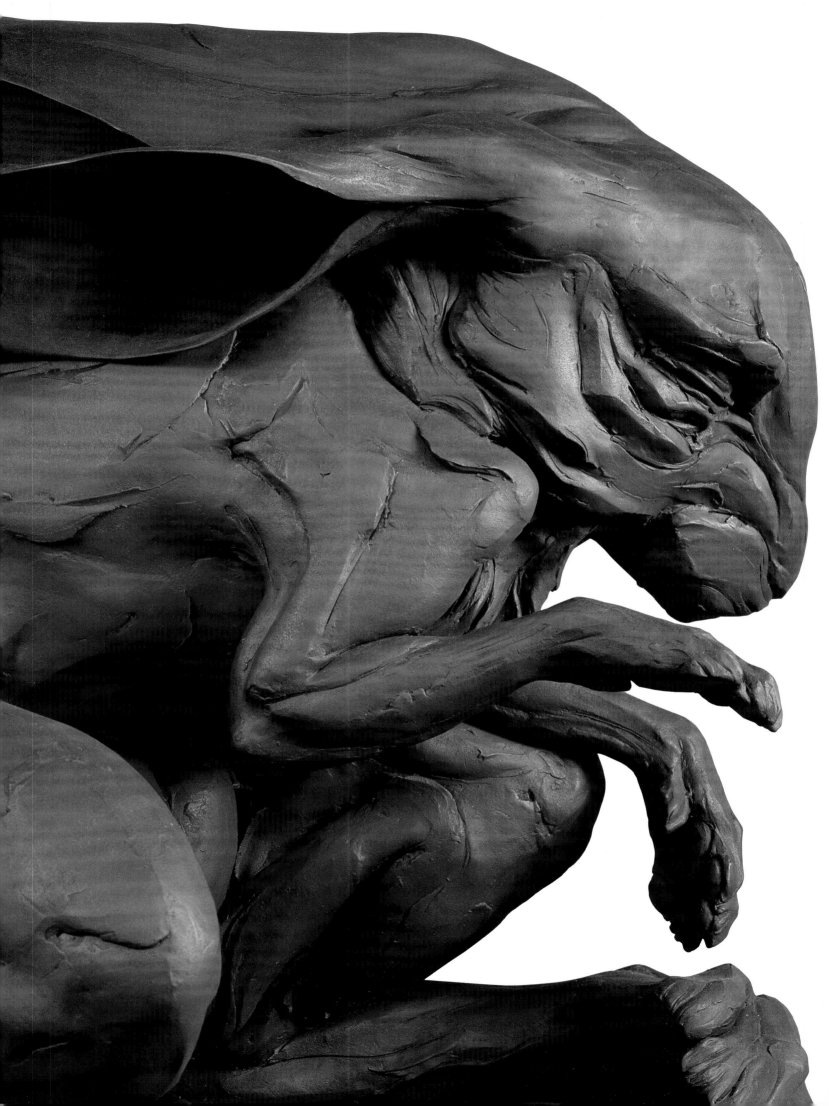

beth cavener stichter

Beth Cavener Stichter's art is marked by her poignant observations of both animal and human nature. Her large sculpted animals move beyond the physical realm into the psychological as they take on a human dimension. The artist points out that they are portraits of specific individuals interpreted in animal form, and that some of her works are inspired by highly personal memories of events in her life. While Stichter's personal experiences are the catalyst for her subject matter, her art leads to universal questions about our humanity. The widespread appeal of animals provides Stichter with a guise to confront us with the biting reality of our human condition. As Stichter explains: "There is a beautiful simplicity among animals. I see so much of us reflected in their bodies and behavior, but somehow even those negative aspects are transformed into something I can accept. I admire the unselfconscious way they live their lives. There is violence and sex and death without pretense. Their physicality and vulnerability define their character." The dramatic postures and predicaments of her animals elicit strong emotional reactions because they remind us of human vulnerability.

As long as Stichter can remember, she has been attracted to the natural world as well as to the sensual quality of clay. Stichter's mother, formerly an art teacher and now also a ceramic artist, and her father, a molecular biologist, encouraged their daughter's analytical and creative abilities. Stichter recalls playing with clay before she learned to speak and views clay as her first language. In her youth she spent summers working in her father's biology laboratory, where she learned to observe objectively and to record animals as specimens. For years she planned to be a scientist, and it was not until college that her curiosity about nature took an artistic turn. She changed her major to sculpture, traveled to Italy to study art, and apprenticed with sculptors in Florence and in Nashville, Tennessee. After college she attended workshops and classes to expand her knowledge of ceramics, and for her graduate work, settled on Ohio State University, Columbus, a program known for its non-traditional approach to ceramic arts.

The ten works in the *Renwick Craft Invitational 2007* represent a selection of Stichter's work over the last three years. The artist's animals—dog, goat, hare, horse, and opossum—appear human through their body language and physiognomy. They are caught up in situations that do not offer a clear interpretation; we must use our imaginations to discover the meaning. Her creatures recall the symbolic roles of animals in allegory, folklore, and mythology. Most are victims, posed or caught in predicaments, laden with conflicting information, and awaiting an uncertain outcome. In works such as *Confessions and Convictions*, *Megrim*, *No Going Back*, and *One Last Word*, the animals are trapped by mechanical elements—

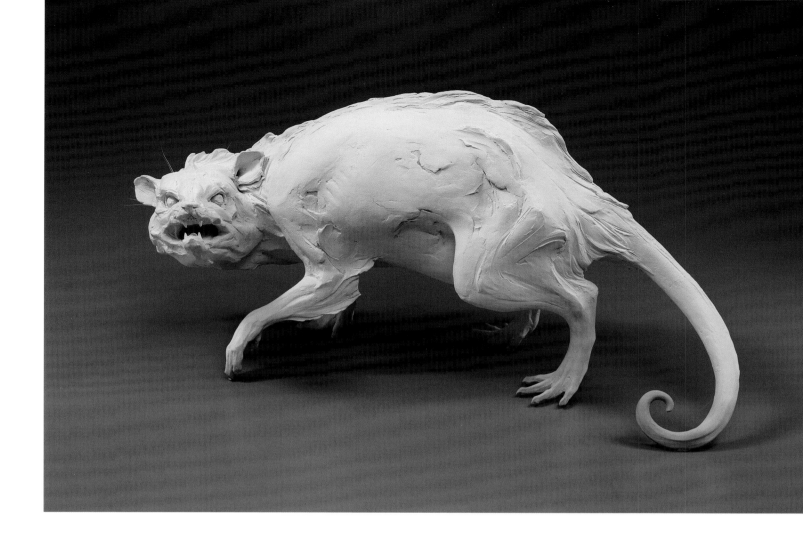

pulleys, ropes, chains, and gears. It is unclear how they arrived there and whether they are partly responsible. These zoomorphic creatures read as metaphors for our human existence, our inner and outer world; how much control do we have and how much is beyond our control? Like the grotesque masks and bestial sculpture that adorn the architecture of medieval cathedrals, Stichter's animals are composites that raise questions about what separates man from beast. Stichter has further humanized *Olympia*, *i am no one*, and *Run* by making their torsos in human scale. Most of Stichter's animals are devoid of their natural protective fur and hair, and instead they are depicted in a vulnerable, naked state that makes them appear more human. *Pleasure* and *please* show us animals in recoiled and defensive poses, as they cower and bare their teeth.

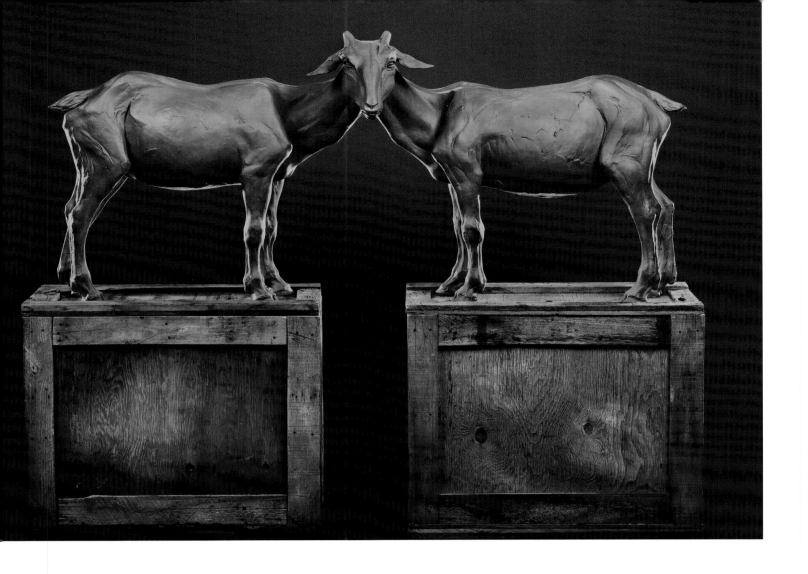

The Inquisitors, 2004,
stoneware, porcelain slip,
wood, and mixed media,
60 ½ × 78 ½ × 24 in.
Collection of Garth Clark and
Mark Del Vecchio

The Inquisitors, the bodies of two goats joined by a single head, provides a thought-provoking amalgam of animal and human behavior. The goat's identification with certain human qualities affects the way we interpret this scene. Goats are known to be somewhat curious, independent, and stubborn. These goats have "put their heads together," and their conformity suggests a herd-like mentality. The goats stand on top of two crates as if on stage and seem to be asking the existential questions—Who am I? And why am I here?

The southern writer Flannery O'Connor relied on distortion, caricature, and the grotesque to communicate the paradoxes of the human condition, stating: "To the hard of hearing you shout, and for the

almost-blind you draw large and startling figures." Stichter relies on the same devices; her provocative animal forms are larger than life and are indeed startling. Distortions of the animals' physiognomy and their body parts—shoulders, arms, legs—and their human postures enhance the drama of Stichter's figures. *Pleasure*, a jackal-like dog, is curled in a fetal position yet bares its teeth. Its serpentine body presses against the wall; a heavily worn leather belt, which at first resembles a collar, is strangling the animal, raising questions about abuse, whether self-inflicted or by torture. The hare in *One Last Word*, despite the conclusive title, is trapped but still kicking. She too is pinned against the wall, collared but still defiant. Though the scene is ominous, some aspect has been left open. The hare's powerful hind legs kick out; she struggles to be free of her bonds, and her slanted and squinting eyes look knowingly out at us. *No Going Back*, which portrays another hare, hanging from a shelf by the tips of its forearms and paws, is darkly comic. The precarious situation of this hare, with its elongated and curved body, is one full of futility. Like O'Connor's characters, Stichter's animals walk the line between survival and death.

Two of Stichter's most recent works, *Olympia* and *Run*, are classical in theme and appearance: a reclining nude and a rearing horse, which are reminiscent of marble sculpture. *Olympia*, a reclining female goat, strikes a seductive pose in which her hind quarter is turned to expose her sexual organs. Blindfolded and on display, she is a mixture of innocence and seduction. The work recalls Édouard Manet's famous painting of the

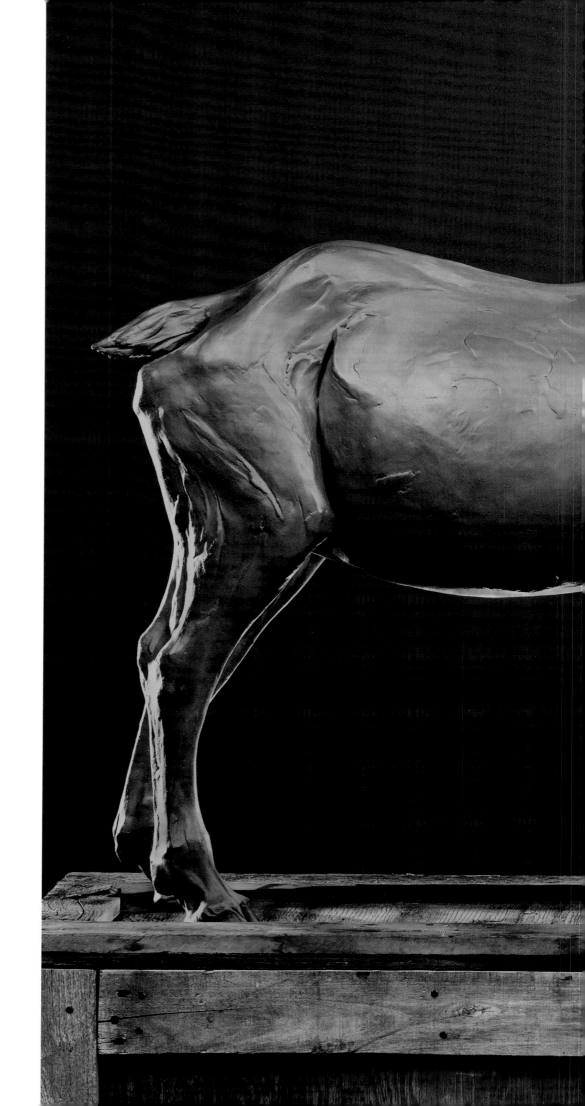

The Inquisitors (detail),
2004, stoneware, porcelain
slip, wood, and mixed media,
60 ½ × 78 ½ × 24 in.
Collection of Garth Clark and
Mark Del Vecchio

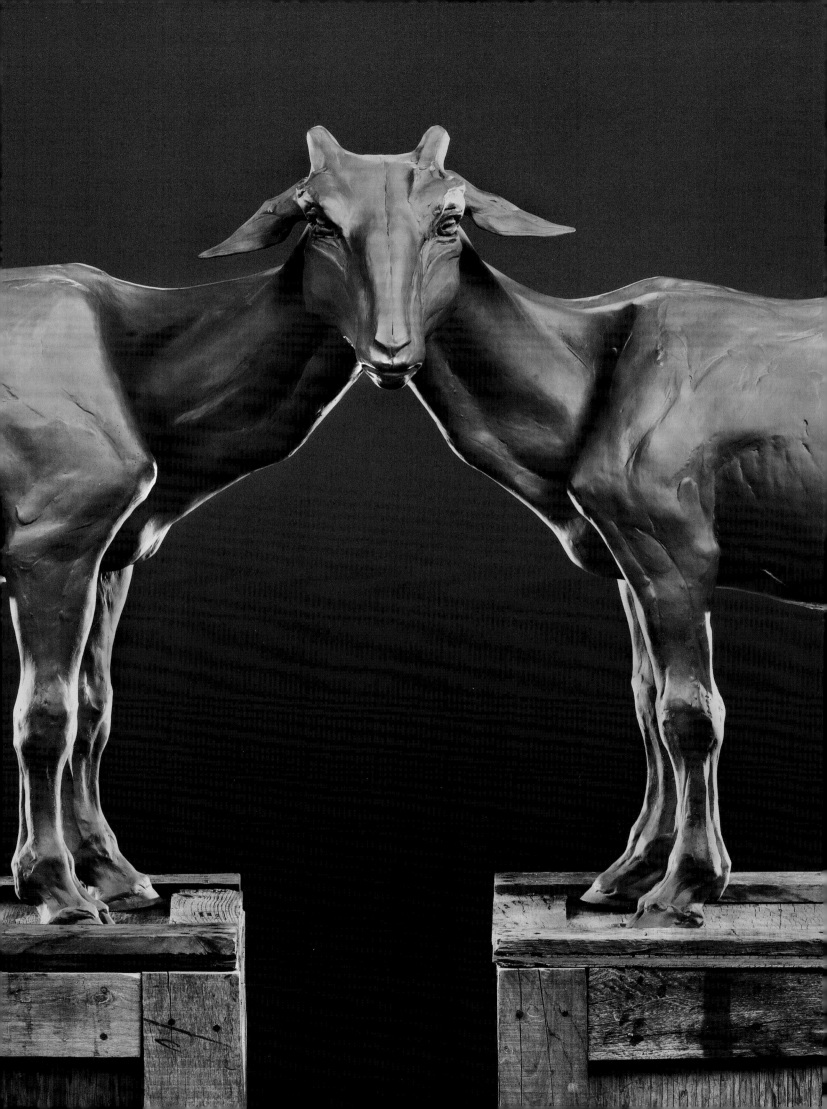

same name, painted in 1863; both take the reclining female nude as their subject. When Manet painted his work, it was considered a risqué and controversial rendering of the goddess of love, Venus. While Manet's model was recognizable as a prostitute, Stichter's *Olympia* is a youthful creature that does not yet seem capable of standing on her own legs. Stichter's ghostly gray horse in *Run* bears a marked resemblance to the rearing horse in Peter Paul Ruben's *The Rape of the Daughters of Leucippus* (1618). Like this painting, Stichter's rendering relies on baroque devices to heighten the drama of her image. The horse's body is twisted and contorted, while its fearful eyes gaze out at us, compelling us to participate in its struggle. The postures of the horse and goat also recall mythological themes in classical art. These art-historical references underscore some of the universal themes in Stichter's work—desire, suffering, and freedom.

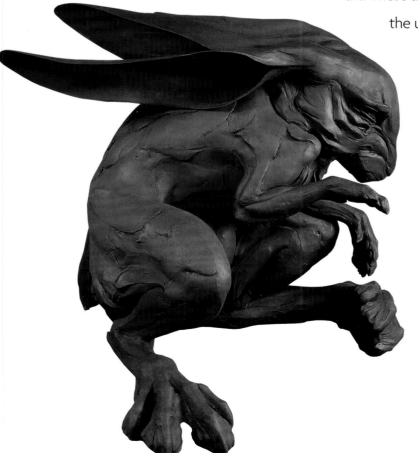

Stichter developed an idiosyncratic construction process to create her large, enigmatic animals. Her approach blends traditional sculpture and ceramic techniques. Departing from the traditions of ceramic sculpture, she models her figures in solid clay and hollows them out as a sculptor would. But unlike most sculptors who would view clay as an intermediary material toward a bronze casting, for Stichter the clay *is* the

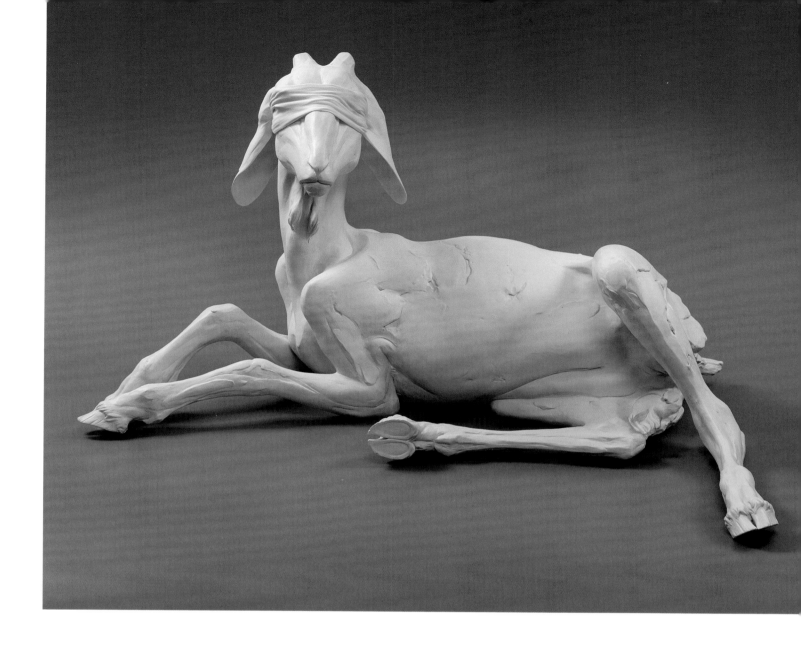

final form. She begins by sculpting hundreds of pounds of clay around steel armatures that sustain the weight and provide initial structure. The modeling stage is extremely physical: she beats, kicks, and pounds the clay, working it quickly so that it remains elastic and holds her marks. After she is satisfied with the modeled form, she dissects the figure into smaller parts, removing it from the armature. She then hollows out each part by hand, smoothing the interior walls to about a quarter inch in thickness; at the same time, she adds definition to the modeled, exterior surface, which looks as if sculpted with a palette knife. She enjoys this laborious,

Olympia, 2006, stoneware, porcelain slip, polyester, and mixed media, 24 ¾ × 44 ½ × 31 ½ in. **Collection of Christine Rémy**

◁

i am no one, 2006, stoneware and mixed media, 32 × 37 × 34 in. **Collection of Michael and Rose Peck**

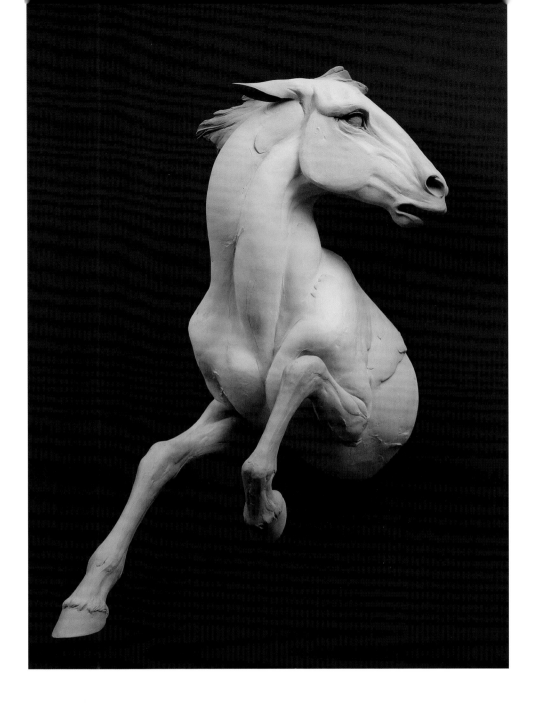

Run, 2006,
stoneware and mixed
media, 40 × 21 × 36 ½ in.
Collection of Karen
Johnson Boyd

meditative process, which allows her to touch every inch of the form, interior and exterior. Her refinement of the surface also structurally enhances the clay walls. Her almost obsessive reworking of the individual parts amazingly reinforces the gestural qualities mapped out in the original, solid form. Her control of fine detail adds to the physicality of the clay, which elastically articulates muscle, bone structure, and sinew. After the work has been fired in the kiln, she rejoins the parts into the whole using epoxy and clay slip so

that the seams are invisible. Stichter's long, painstaking process of modeling, deconstructing, and reconstructing results in sculptures that are astonishing in scale and realism.

Like Stichter's construction methods, her selection and application of color are deliberate and exacting. While she uses some traditional glazing methods in finishing her work, such as porcelain slips colored with oxides, she also applies paint after the work is fired in the kiln—breaking a cardinal rule of ceramics. She generally selects an earthy palette and matte surface, which accentuates the primordial qualities of her work. She chooses colors that reinforce or overturn the viewer's immediate response to the animal's condition. Stichter discovered that most flat interior decorative wall paints contain a high percentage of kaolin, essentially ninety-five percent clay, which explains why it resembles a dry, matte ceramic surface. Stichter deliberately selects colors from Martha Stewart's designer color line that have such romantic, sentimental names as "Lost Mitten Blue" (obviously invented to associate the color with a desired mood for a room), and slyly applies these colors to achieve the direct opposite of the effect suggested by the name of the paint. For example, *please*, which depicts an opossum with bared teeth posed in a defensive posture, is painted with "Intimate White" and "Romance." *i am no one*, a wounded and cowering hare, is covered in deep, rich "Miso Red," which in a room interior might be associated with romantic and exotic luxury; in Stichter's work it evokes pain and suffering.

The earthy, visceral qualities of Stichter's work joins contemporary ceramic sculpture to the long tradition of depicting animals in art. In the

recent decades, figurative ceramic sculpture in America has largely included the human figure or objects or both, but rarely animals. Works by such artists as Robert Arneson, Jack Earl, Viola Frey, Michael Lucero, and Patti Warashina run the gamut in scale and style, but all these artists have relied on traditional ceramic construction and glazing techniques. Their work paved the way for a generation of ceramic artists in the twenty-first century, such as Stichter, who use clay because it is a malleable and responsive sculptural material, not because they are immersed in the

Pleasure, 2006, stoneware and mixed media, 29 ½ × 33 × 17 in. Courtesy of Garth Clark Gallery

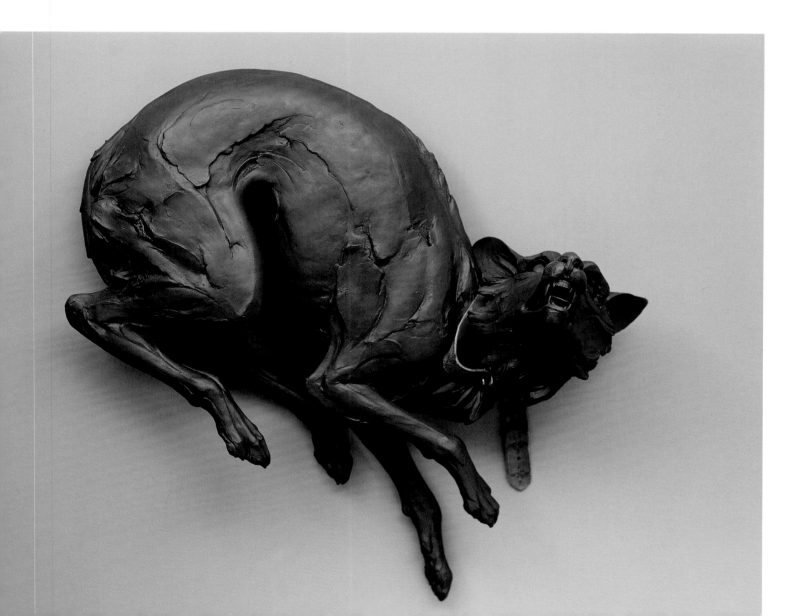

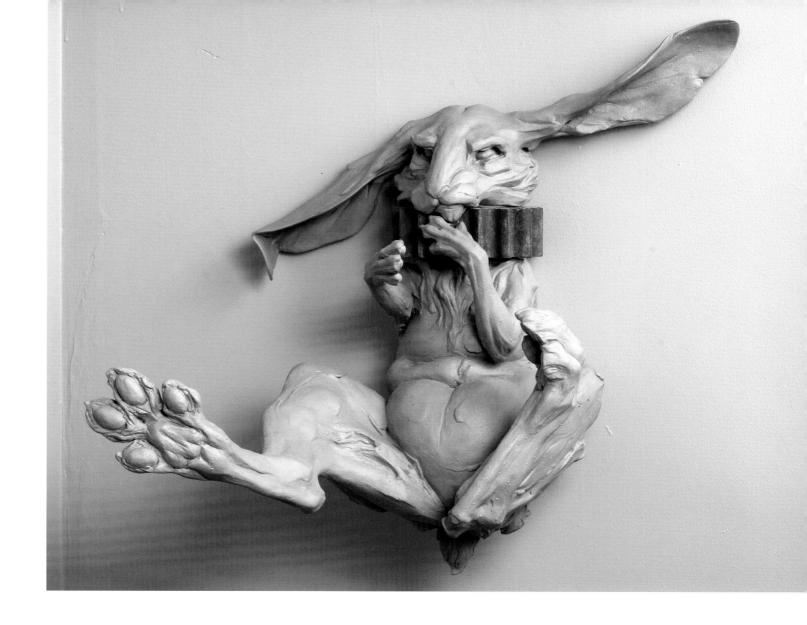

ceramic tradition. Stichter maintains almost complete control over her work, from conception to completion. Though she integrates other media, such as wood, steel, leather, and paint, these are props that enhance the subject of the work. Like the other artists in the *Renwick Craft Invitational 2007*, she is well versed in the rudiments of her craft, but she is not afraid to employ all kinds of techniques and materials to achieve a desired result. Her unorthodox methods have propelled her work forward and set it apart as finely crafted sculpture. Not only does she have something to say, she has found a powerful way to say it. **JANE MILOSCH**

One Last Word, 2005, stoneware, porcelain slip, and iron, 26 × 23 × 23 in. Collection of Marge Brown and Philip Kalodner

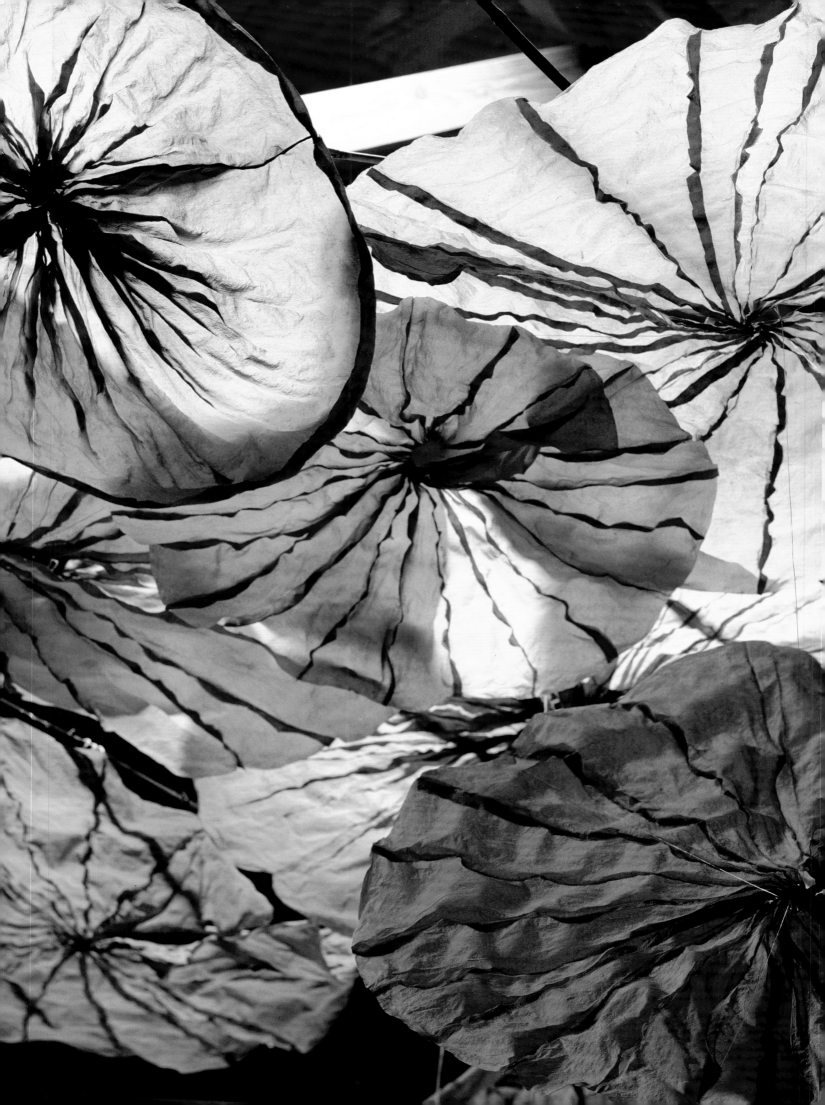

jocelyn châteauvert

There is a rhythm to hand papermaking that is at once highly physical and meditative. Working the fibers and water back and forth to get just the right amount onto the mold, the papermaker feels her way through the forming process. These gestural movements are captured in the surface of the paper. In the hands of paper artist Jocelyn Châteauvert, the process and the intrinsic beauty of paper are drawn out for an expressive end. In the dance between craft artists and their materials, the artist simultaneously leads and follows, using knowledge of the material's physical properties and the creation process to move from raw material to finished product. Over the last eighteen years, Châteauvert's craftsmanship and vision have led her to create paper jewelry, lighting designs, and installations that engage the senses.

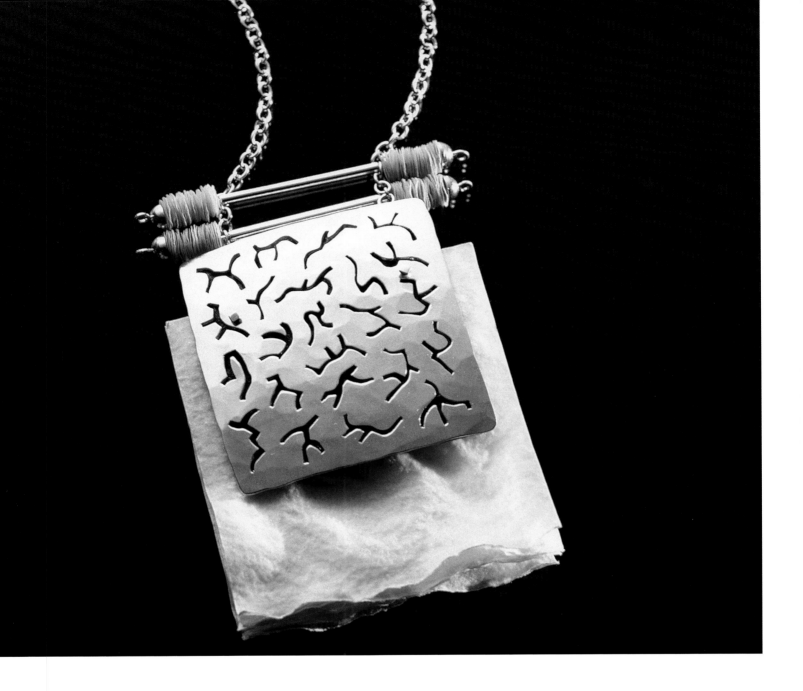

**Volume I, Pulp Fiction Series,
1996, abaca and sterling sil-
ver, 2 ¼ × 2 ⅞, chain 33 ½ in.
Collection of Laurie and
Charles Bails**

◁◁
**Lily Clouds, 2006,
flax and fine silver,
120 × 207 × 226 in.
Collection of the artist**

First trained as a metalsmith, Châteauvert gradually converted
to papermaking as her primary medium, fueled by her discovery that
handmade paper as an artistic medium for jewelry had not been fully
explored. A native Iowan, she earned both her undergraduate degree
in design and a master's degree in jewelry and metalwork at the
University of Iowa. Châteauvert developed her technical knowledge
and appreciation for craft through two exceptional teachers and in-

novators: Chunghi Choo, an internationally renowned metalsmithing artist, and Timothy Barrett, one of the foremost scholars and craftsmen in the art of hand papermaking. Choo's pedagogical approach stems from her studies at the Cranbrook Academy of Art, which, in a tradition similar to that of the Bauhaus, emphasizes the integration of craft and fine arts, challenging students to become artists and consummate craftsmen through knowledge of their materials and process. Barrett's groundbreaking research and revival of hand papermaking techniques led to its introduction into college art curriculums across the country, especially in conjunction with the book arts and printmaking. These two luminaries set high standards for Châteauvert's work.

While still in graduate school, Châteauvert won numerous prizes and garnered international attention for her jewelry, and she slowly began to introduce handmade paper into her designs. The possibilities of combining silver with handmade paper intrigued Châteauvert, as she realized that the opposite physical characteristics of these materials enhanced each other. The silver also gave the paper jewelry "clout" it would not have had on its own. This combination was not only a breakthrough for the artist; it was also heralded as highly innovative and beautiful within the world of contemporary, artist-made jewelry.

Châteauvert primarily makes paper from abaca fibers, derived from the banana plant, but she also uses flax. She employs traditional Western papermaking techniques to form her sheets, often overbeating the fibers. For many papermakers the unique beauty of the sheets is

enough, and they would not consider trying anything unorthodox with it; this is not the case for Châteauvert, who relishes a bit of irreverence in her art. She works the paper, both wet and dry, in a variety of ways: cutting, scoring, folding, molding, layering, and sewing these sheets, so that in the end it is difficult to see that she started with a flat sheet.

Châteauvert explains: "The metalwork complements the paper, the opaque with the translucent, and the reflective with the light absorbing. But I have started some all-paper pieces, and that is really the future of the work. Because of the inherent strength of the paper, I don't use the metal to make the paper stronger." In fact, she discovered that in most cases, the paper provided the strength and structure for the silver. Most of Châteauvert's recent work leaves silver behind in order to focus on the inherent, contrasting properties of handmade paper alone: pliability and resilience, roughness and smoothness, translucence and opaqueness.

Wit and the ability to shed the superfluous, to get down to the bare essentials, characterize Châteauvert's work. When asked how long it took to make *Eve, (Clothes Optional)*, Châteauvert responded "all my life." This fig-leaf pendant, which hangs from a long chain, ingeniously touches on our ideas about adornment and how we cover our body. Reversing the events of the biblical account, not long after the creation of *Eve*, Châteauvert made *Adam*. Later, she introduced *Naked Forest* as a backdrop for displaying this pairing. Her humor reveals itself again in her series of pins, pendants, and earrings based on vacuum cleaners,

▷

Eve, (Clothes Optional),
1994, abaca and sterling silver, 6 ¼ × 5 × ¾ in., chain 56 in.
Collection of the artist

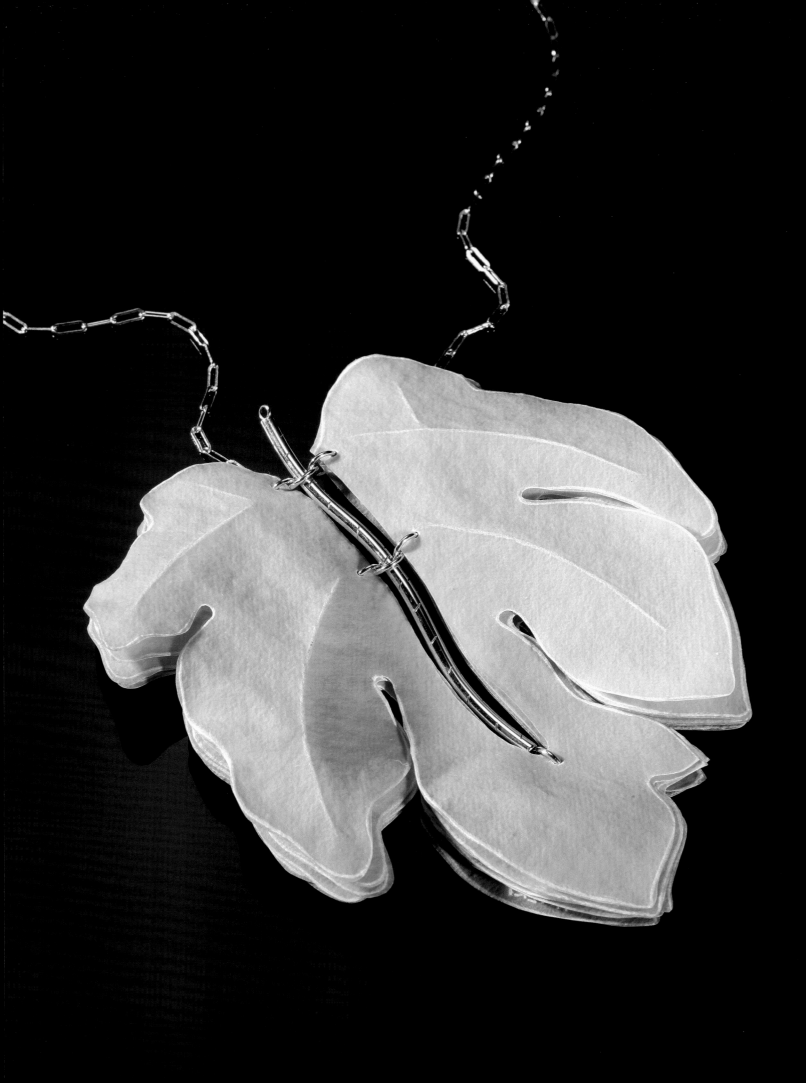

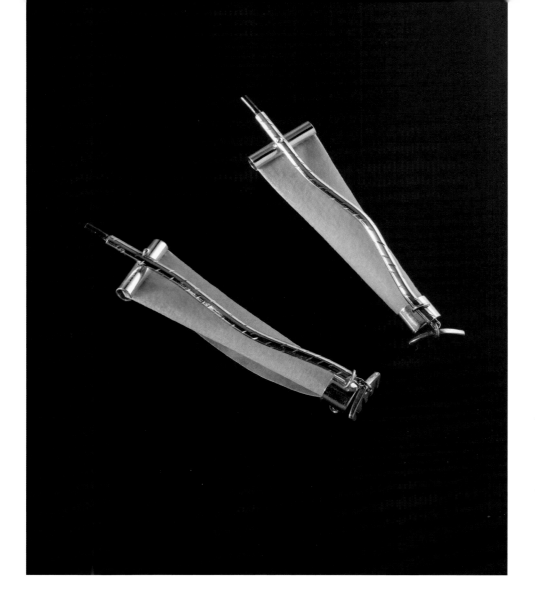

Upright/Upstarts, 1996,
abaca, sterling silver, and
copper, 3 × ⅝ × ¾ in. (each)
Collection of the artist

which Châteauvert jokingly says she invented because, at times, "life sucks." *Upright/Upstarts* and *Electrolux*, miniature interpretations of vacuums as earrings and a pendant, whimsically draw attention to a contraption that would look ridiculous if we did not know its function. *Pulp Fiction, Volume I*, the first in a series of miniature artist books, reinterprets the age-old idea of a locket. The pages of these books are empty, as the luxury of the paper and silver serves as a tactile language.

Most of Châteauvert's paper-silver jewelry moves and rustles when it is worn, welcoming touch and adding a sensuous dimension. *Mother's Tongue*, a necklace whose irreverent title references the fact

that the piece is both felt and heard, invites interaction through the visual appeal of the silver tentacles and the noise of the paper. Châteauvert's bracelet *Black Globe* is also designed to move on the body. As it rolls up and down the arm, the bracelet's hollow paper globes stretch and flatten but bounce back to their original form in the end. The scored lines and simple geometry are in constant play.

Around 1998, Châteauvert shifted her focus from jewelry to lighting design but continued to produce works that were almost exclusively paper, rarely including silver or any other visible material. As she illuminated her paper, she saw the great expressive potential of

Electrolux, 1996,
abaca and sterling silver,
¾ × 3 ½ × ¼ in.
Collection of the artist

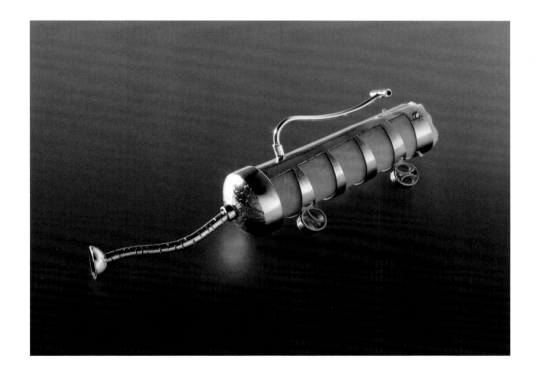

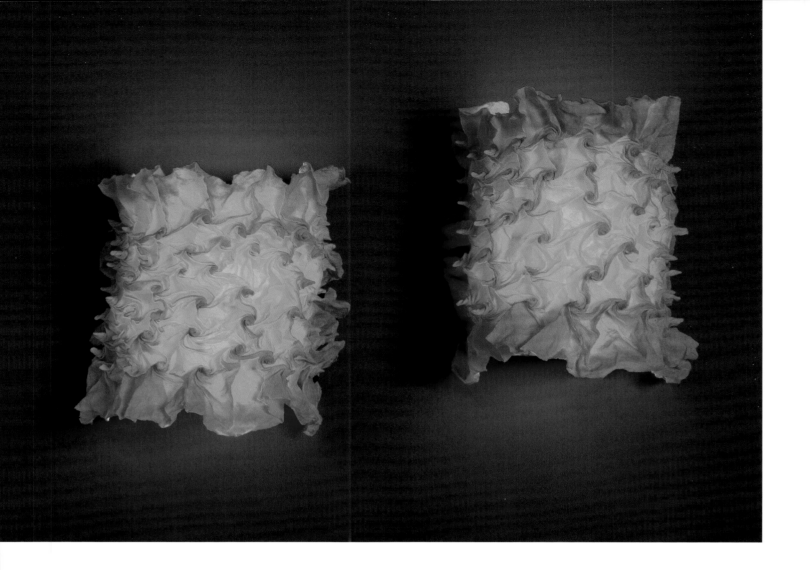

**Pink Boudoir (detail), 2006,
abaca and mixed media,
9 × 9 × 6 in. (pair)
Collection of the artist**

the material and experimented with forms that would accentuate its intrinsic beauty. Natural forms served as inspiration for her wall sconces, pendant lamps, and floor lamps. *Fresh*, a giant sunflower, is radiantly reminiscent of flowers soaking up the sun. Serving as a wall light, the center of the flower glows. The design was a reinterpretation of her necklace *Homage,* also in the shape of a sunflower. *Pink Boudoir*, a series of sconces which look as if they could have flanked Madame de Pompadour's dressing table, are rococo in color and design. An element of seduction occurs with the intermingling of the red and white layers as they create pink. The layers are pinched, twisted, and manipulated so that the end effect is that of many little rose buds. *Migration*, made

of pierced, cut, and sewn cascading paper, has a festive and mysterious appearance. Its light-filled core allows the paper to glow, creating a mingling of light, shadows, movement, and sound.

Bigger is not always better, but in Châteauvert's case, her vision increased proportionally with the scale of her work. Paper walls that move, flooring that glows, ceilings that float—Châteauvert demonstrates endless possibilities with her paper environments. Establishing her studio on the coast of South Carolina introduced her to a world of natural waterways, and the inspiration provided by this landscape is apparent in the subject matter of her work: wetlands, grasses, and swampy forests. *Marsh Grasses IV* is constructed from a continuous roll of grassy-looking paper, illuminated from below, which can be arranged in endless variations. *Scratch,* an enormous paper curtain, hangs in three layers. Walnut and red pigments in two of the layers introduce warmth and contrast to the natural material. Perforations, pleats, dimples, subtle marks, and aggressive manipulation highlight the tactility and resilience of the paper. Light dances between the layers, shadows introduce drama, and the rustle of the layers completes the sensory experience of the piece. Shaped like lily pads but floating like clouds, *Lily Clouds*, an installation of handmade paper and sterling silver, is designed to bring the natural world inside. The hybrid forms of the piece, which are suspended from the ceiling, invite the viewer to navigate a course through a shimmering water garden, as the gentle swaying of the pads recalls the watery waves in which the paper was made.

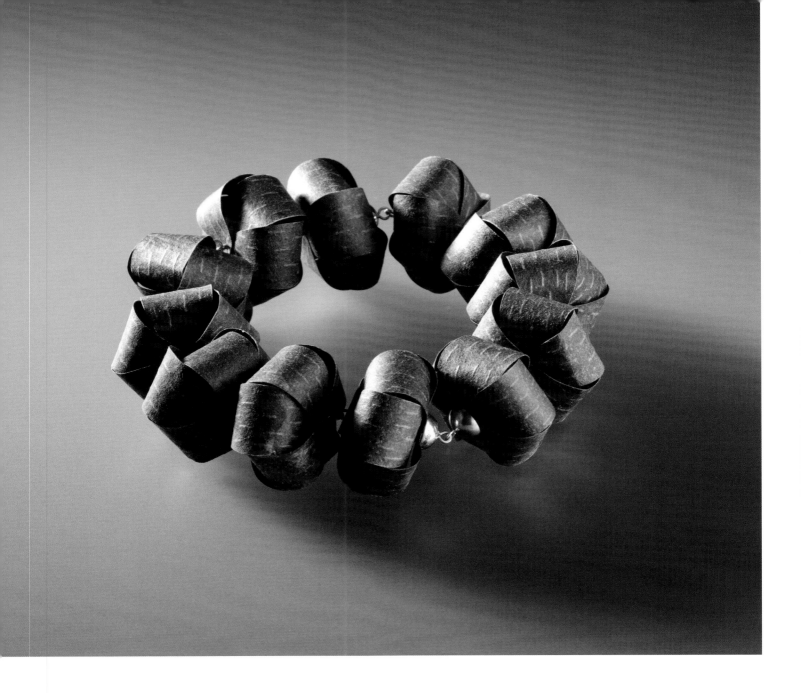

Black Globe, 1998,
abaca and pigment,
1 ⅜ × 4 ½ in. diam.
Collection of the artist

▷

Mother's Tongue, 1995,
abaca and sterling silver,
25 × 3 × 1 ½ in.
Collection of the artist

Handmade paper has long been important only as a two-dimensional material, a ground or foundation for other materials and work, such as printmaking and artists' books. In her explorations of handmade paper, Châteauvert has, however, transferred this "support" material to the focal point of her jewelry, lighting designs, and installations. Her works are playful interludes with light and drama, treated with a twist of humor, that come together and yield a fresh vision in handmade paper. **JANE MILOSCH**

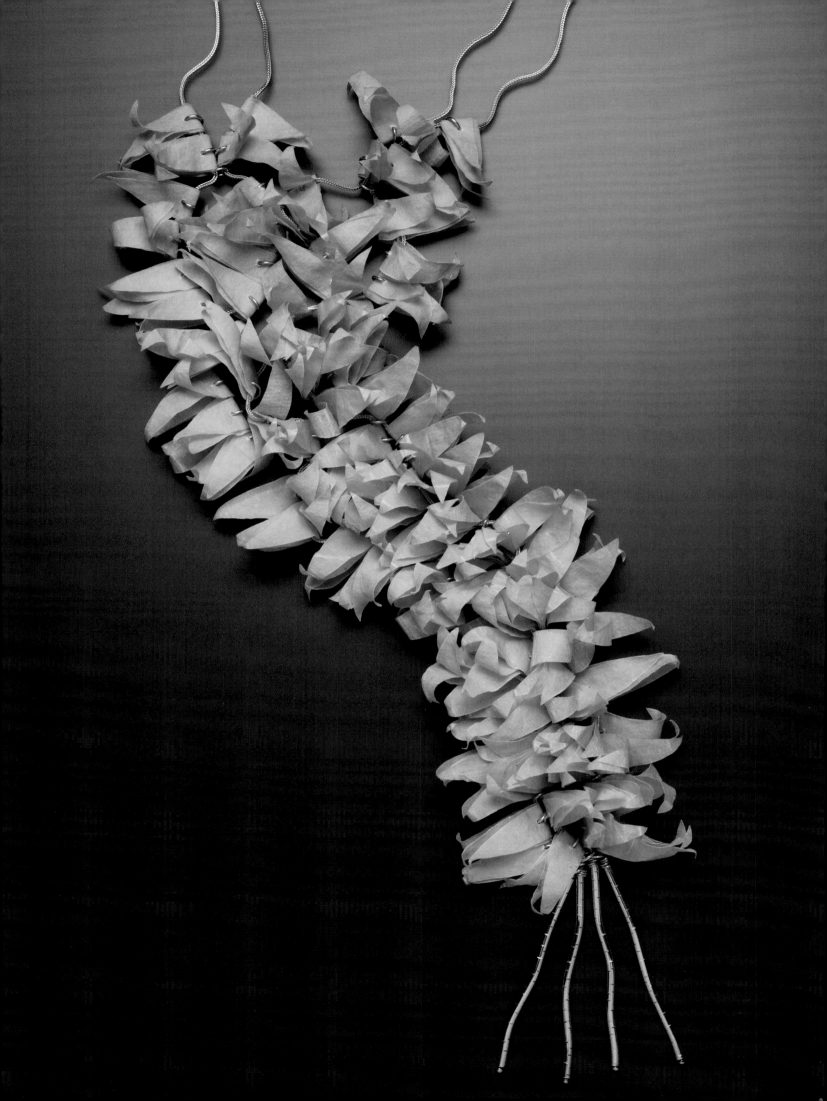

exhibition checklist

paula bartron

Black Box, 1992
sand-cast and fused glass
10 × 14 × 14 in.
Collection of the artist

Tall Green Box, 1992
sand-cast and fused glass
20 ¾ × 8 × 8 in.
Collection of the artist

Blue Disks, 1997
sand-cast glass
28 disks, each 2 ¼ × between
15 ½ and 15 ¾ in. diam.
Collection of the artist

Long White Basin, 1998
sand-cast and fused glass
2 ½ × 49 ½ × 14 in.
Collection of the artist

Pair of Gray Cylinders, 1999
blown and sand-cast glass
with glass powders
8 ½ × 9 in., 9 ¼ × 8 ⅝ in.
Collection of the artist

Red Cylinder, 2004
blown and sand-cast glass
with glass powders
11 × 9 ⅞ in. diam.
Collection of the artist

White Cylinder, 2004–2005
blown and sand-cast glass
with glass powders
12 ¾ × 10 ¾ in.
Collection of the artist

Black Basin, 2005
sand-cast and fused glass
1 ½ × 30 ¼ × 11 ½ in.
Collection of the artist

Black Cylinder, 2006
blown and sand-cast glass with
glass powders
15 ¾ × 15 ⅜ in. diam.
Collection of the artist

beth lipman

Enzo's, 2001
hand-sculpted and blown glass,
wood veneer, and mixed media
28 × 22 ½ × 18 in.
Courtesy of Heller Gallery

*Cupboard Picture with Flowers, Fruit,
and Goblets (after Flegel)*, 2002
hand-sculpted, blown, kiln-formed,
and lampworked glass, wood veneer,
acrylic, and mixed media
35 ¾ × 27 ⅝ × 14 in.
Collection of Sharon Karmazin

Bancketje (Banquet), 2003
hand-sculpted, blown, kiln-formed,
and lampworked glass with gold paint,
oak, oil, and mixed media
67 × 50 × 240 in.
Courtesy of Heller Gallery

*Basket of Fruit (after Michelangelo
Caravaggio)*, 2003
hand-sculpted, blown, and kiln-formed
glass with gold leaf and gold luster,
wood, and mixed media
32 × 40 × 10 in.
Private Collection

Black Swag (after Jan van Kessel), 2003
glazed porcelain
18 × 36 ½ × 5 ¼ in.
Private Collection

*Dead Birds (after Frans Cuyck
van Myerop)*, 2003
hand-sculpted glass, wood,
oil, and mixed media
43 ¾ × 31 ¾ × 3 ¼ in.
Collection of Bill Fick and
Kristen Hondros

Cherries (after Sarah Miriam Peale), 2005
hand-sculpted, flameworked glass and
mixed media
13 × 11 × 4 in.
Courtesy of Heller Gallery

Stilleven (after Willem Claesz Heda), 2005
hand-sculpted, blown, kiln-formed, and
lampworked glass, oak, and paint
58 × 47 ½ × 27 ½ in.
Collection of Nancy and Philip Kotler

Tea Table II, 2005
hand-sculpted, blown, kiln-formed, and
lampworked glass, gold lustre, and wood
48 ½ × 34 in. diam.
Collection of Anna and Joe Mendel,
Montreal, Canada

Large Bouquet, 2006
hand-sculpted, blown, kiln-formed,
lampworked, and sandblasted
glass with oil
48 × 38 × 6 in.
Courtesy of Heller Gallery

beth cavener stichter

Confessions and Convictions, 2004
stoneware, porcelain slip, and rope
21 × 22 × 56 in.
Collection of Stephen and Pamela
Hootkin

No Going Back, 2004
stoneware, porcelain slip, and wood
19 × 10 ½ × 4 ½ in.
Collection of Pat Sullivan and Jim Kolva

The Inquisitors, 2004
stoneware, porcelain slip, wood,
and mixed media
60 ½ × 78 ½ × 24 in.
Collection of Garth Clark and
Mark Del Vecchio

Megrim, 2005
stoneware, steel, wooden yoke,
and rope
30 × 18 × 45 in.
Private Collection

One Last Word, 2005
stoneware, porcelain slip, and iron
26 × 23 × 23 in.
Collection of Marge Brown and Philip
Kalodner

please, 2005
stoneware, cat whiskers,
and mixed media
14½ × 27 × 13 in.
Collection of Robin and Danny
Greenspun

i am no one, 2006
stoneware and mixed media
32 × 37 × 34 in.
Collection of Michael and Rose Peck

Olympia, 2006
stoneware, porcelain slip, polyester,
and mixed media
24¾ × 44½ × 31½ in.
Collection of Christine Rémy

Pleasure, 2006
stoneware and mixed media,
29½ × 33 × 17 in.
Courtesy of Garth Clark Gallery

Run, 2006
stoneware and mixed media
40 × 21 × 36½ in.
Collection of Karen Johnson Boyd

jocelyn châteauvert

Eve, (Clothes Optional), 1994
abaca and sterling silver
6¼ × 5 × ¾ in., chain: 56 in.
Collection of the artist

Mother's Tongue, 1995
abaca and sterling silver
25 × 3 × 1½ in.
Collection of the artist

Adam, 1996
abaca and sterling silver
8¼ × 7 × ¾ in., chain: 62 in.
Collection of the artist

Electrolux, 1996
abaca and sterling silver
¾ × 3½ × ¼ in.
Collection of the artist

Upright/Upstarts, 1996
abaca, sterling silver, and copper
3 × ⅝ × ¾ in. (each)
Collection of the artist

Volume I, Pulp Fiction Series, 1996
abaca and sterling silver
2¼ × 2⅞ in., chain: 33½ in.
Collection of Laurie and Charles Bails

Homage, 1997
abaca and sterling silver
⅞ × 6 in. diam., chain: 14 in.
Collection of the artist

Ophelia, 1997
abaca and sterling silver
6 × ¼ in.
Collection of the artist

Wiggle, 1997
abaca and sterling silver
4 × 1 × 1 in., chain: 16½ in.
Collection of Dr. Charles H. Read
and Chunghi Choo

Black Globe, 1998
abaca and pigment
1⅜ × 4½ in. diam.
Collection of the artist

Scrunch, 2003
flax
3½ × 5 × 2½ in.
Collection of Nina Liu

Fresh, 2005
abaca and mixed media
7 × 20 in. diam.
Collection of the artist

Lily Clouds, 2006
flax and fine silver
120 × 207 × 226 in.
Collection of the artist

Marsh Grasses IV, 2004–2006
abaca and mixed media
20 × 60 × 132 in.
Collection of the artist

Migration, 2006
abaca and mixed media
60 × 17 × 13 in.
Collection of the artist

Naked Forest, 2006
abaca and black walnut dye
120 × 36 × 22 in.
Collection of the artist

Pink Boudoir, 2006
abaca and mixed media
9 × 9 × 6 in. (pair)
42 × 16 × 8 in.
Collection of the artist

Scratch, 2006
abaca, walnut dye,
and pigment
144 × 120 × 12 in.
Collection of the artist

paula bartron

Glass artist Paula Bartron focuses on cast objects and cylinder forms that she characterizes as "simple, scaled down, minimal, and intended in part to relate to 'the primitive'." Born in San Mateo, California, in 1946, Paula Bartron studied at the University of California, Berkeley, earning a B.A. in Design in Ceramics and Glass in 1970, and an M.A. in Design in Glass in 1972 under Marvin Lipofsky. After graduating, Bartron moved to Europe with the intent of achieving greater technical expertise in glass. In 1972 she attended the symposium *Glas Heute: Kunst oder Handwerk? (Glass Today: Art or Craft?)*, one of the seminal events in studio glass history. The following year she became one of the first Americans to study at the Orrefors Glass School in Sweden. She then worked in Finland as an apprentice under Kaj Frank and Oiva Toikka. In 1975 Bartron started the studio glass program at Konstfack (University College of Arts, Crafts, and Design) in Stockholm, Sweden, where she lives and works.

Since starting the glass program at Konstfack, Bartron has studied with such glass masters as Dale Chihuly, Lino Tagliapietra, Stanislav Libenský, and Jaroslava Brychtová. She has also traveled to Venice, Italy, and to Nový Bor in the Czech Republic, to blow glass. Although Bartron is American, her years in Sweden have greatly influenced her, and her work represents the Swedish aesthetic. Her work has been exhibited in shows throughout the world, including *Design 4 Elements—Contemporary Swedish Design*, Frankfurt Fair, Frankfurt, Germany; *International Exhibition of Glass Kanazawa 2001*, Design Center Ishikawa, Kanazawa, Japan; and *The Sixth São Paulo Biennial of Architecture and Design*, São Paulo, Brazil. Additionally, she is a three-time recipient of the Stockholm City Artists Grant and a four-time recipient of the Swedish State Artists Grant.

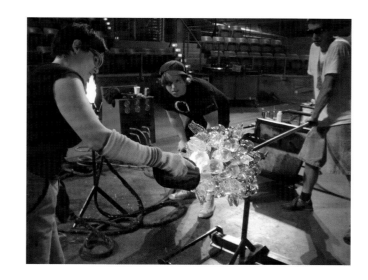

beth lipman

Master glass artist Beth Lipman has earned renown for her sculptural interpretations of baroque and American still-life paintings, particularly seventeenth-century Dutch banquet tables. Blending sculpture and painting, she works primarily in hand-sculpted glass to recreate the bounty and visual sumptuousness that have characterized still lifes, but with an added element. Glass, Lipman explains, "creates a tangible third dimension, capturing the painting's polished quality. Its transparency suggests an ideal form, the essence of an object." Born in Philadelphia in 1971, Lipman earned her B.F.A. from Tyler School of Art, Temple University, in 1994, and has received grants from the Louis Comfort Tiffany Foundation, Peter S. Reed Foundation, the New Hampshire State Council on the Arts/National Endowment for the Arts, and the Ruth Chenven Foundation.

Lipman's work has greatly benefited from several Artist-in-Residence programs, including programs at The Studio at the Corning Museum of Glass, Corning, New York; the John Michael Kohler Arts Center, Sheboygan, Wisconsin; and the Museum of Glass, Tacoma, Washington. These residencies afforded her a team of glass artists to assist with large-scale works. Lipman's tour de force *Bancketje* (2003) was created during a residency at the Wheaton Arts and Cultural Center in Millville, New Jersey, and later exhibited at such venues as the Fuller Craft Museum, Brockton, Massachusetts; the Heller Gallery, New York City; and SOFA Chicago. Lipman served as the education director at UrbanGlass from 1997 to 2000, and she has taught at Pratt Fine Art Center, New York University, Parsons School of Design, and the Bard Graduate Center. Since 2005 she has served as the Arts/Industry Coordinator of the Artist-in-Residence program at the John Michael Kohler Arts Center. Most recently she was awarded the 2006 UrbanGlass Award for New Talent.

beth
cavener stichter

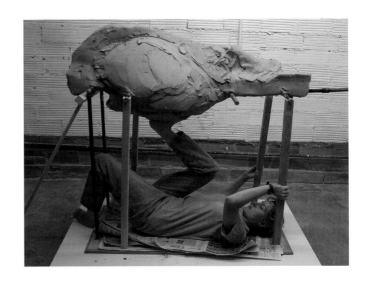

Beth Cavener Stichter's clay sculptures combine the natural and the surreal. "The sculptures I create focus on human psychology…gestures that betray intent and motivation," explains the artist. "I rely on animal body language in my work as a metaphor for these underlying patterns, transforming animal subjects into human psychological portraits." Stichter graduated with a B.A. in Sculpture from Haverford College, Haverford, Pennsylvania, in 1995, and later studied at the Appalachian Center for Craft in Tennessee and completed an M.F.A. in Ceramics at Ohio State University in 2002. In addition to her academic training, Stichter apprenticed with a sculptor in Nashville, Tennessee, and at the Charles H. Cecil Studios in Florence, Italy.

Several Artist-in-Residence programs have played an important role in Stichter's ability to focus on her work and experiment with techniques, especially residencies at the Archie Bray Foundation in Helena, Montana; The Clay Studio in Philadelphia; and,

most recently, Pottery Northwest in Seattle. These guest residencies have been augmented by several grants, such as an Emerging Artist Grant from the American Crafts Council, an artist fellowship from the Ohio Arts Council, and the prestigious first-prize award from the Virginia A. Groot Foundation in 2005. Stichter's work has appeared in both solo and group exhibitions across the country, including shows at the Contemporary Crafts Museum in Portland, Oregon, and the Garth Clark Gallery in New York City, and she has been recognized with numerous awards and honors, such as best of show in the St. Petersburg (Fla.) Clay National Juried Exhibition. Born in California in 1972, Stichter now lives in Portage, Ohio.

jocelyn châteauvert

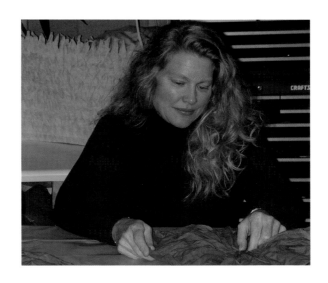

Paper artist Jocelyn Châteauvert uses traditional paper-making techniques and plant fibers to create paper that she then transforms into jewelry, lighting designs, and large-scale environments. The artist says, "I am in continuous dialogue with the material itself. I allow my hands to respond to the paper and inform me." Born in Iowa in 1960, Châteauvert earned a B.A. in Design in 1984, and an M.F.A. in Jewelry and Metalwork in 1990 from the University of Iowa, where she studied with renowned metalsmith artist Chunghi Choo and internationally recognized papermaker Timothy Barrett. Her paper jewelry first garnered attention while she was in graduate school.

In 1990 Châteauvert was an Artist-in-Residence at Middlesex Polytechnic in London, England, where she taught the electroforming process to their metalsmithing department. She returned to the United States to launch a limited production line of jewelry designs, based out of San Francisco and later Mount Vernon, Iowa. In 1998 Châteauvert added lighting designs to her production line, with her works exhibited and sold through competitive retail craft expositions and in art galleries across the country, including the Smithsonian Craft Show and Aaron Faber Gallery in New York. Her installation work has been commissioned for and exhibited in the Charleston County Public Library, the Circular Congregational Church in Charleston, and numerous other public spaces. Châteauvert lives and works in Charleston, South Carolina, with her husband David Ross Puls, a studio furniture maker. Among other honors, she was awarded a 2005 Craft Fellowship from the South Carolina Arts Commission and a first-place award for her lighting designs from NICHE Magazine.

selected bibliography

Bova, Joe. *500 Animals in Clay: Contemporary Expressions of the Animal Form*. Asheville, N.C.: Lark Books, 2006.

Clark, Garth. *Beth Cavener Stichter*. New York: Garth Clark Gallery, 2006.

Frantz, Susanne K. *Contemporary Glass: A World Survey from the Corning Museum of Glass*. New York: Harry N. Abrams, 1989.

Frantz, Susanne K., Yoriko Mizuta, and Helmet Ricke. *The Glass Skin*. Corning, N.Y.: Corning Museum of Art, 1998.

Frantz, Susanne K. and Gay Le Cleire Taylor. *20/20 Vision*. Millville, N.J.: Museum of American Glass, 2002.

Game, Amanda and Elizabeth Goring. *Jewelry Moves: Ornament for the 21st Century*. Edinburgh, Scotland: National Museums of Scotland, 1998.

Gunter, Veronika Alice, ed. *500 Figures in Clay: Ceramic Artists Celebrate the Human Form*. Asheville, N.C.: Lark Books, 2004.

Herman, Lloyd E. *Art That Works: The Decorative Arts of the Eighties, Crafted in America*. Seattle: University of Washington Press, 1990.

————. *Looking Forward, Glancing Back: Northwest Designer Craftsmen at Fifty*. Seattle: University of Washington Press with the Whatcom Museum of History & Art, 2004.

Kohler, Lucartha. *Women Working in Glass*. Atglen, Pa.: Schiffer Publishing, 2003.

Krupenia, Deborah and Boo Poulin. *The Art of Jewelry Design*. Cincinnati: North Light Books, 1997.

Milosch, Jane. *Forging Ahead: Contemporary Metalwork in Iowa*. Davenport, Iowa: Davenport Museum of Art, 1997.

Netzer, Susanne. *Museum für Moderne Glas*. Edited by Joachim Kruse. Coburg, Germany: Kunstsammlungen der Veste Coburg, 1989.

Sellner, Christiane. *Geschichte des Studioglases*. Theuern, Germany: Bergbau und Industriemuseums Ostbayern, 1984.

South Carolina State Museum and South Carolina Arts Commission. *Triennial 2004*. Columbia, S.C.: South Carolina State Museum and South Carolina Arts Commission, 2004.

Yelle, Richard Wilfred. *International Glass Art*. Atglen, Pa.: Schiffer Publishing, 2003.

image credits

notes

paula bartron

Back Cover: photo by Gene Young

Frontispiece: photo by Gene Young

Pages 16–20: photos by Gene Young

Page 72: Paula Bartron, working at the Glass
Symposium in Nový Bor, Czech Republic, 2000.
Photo by Susanne Frantz.

beth lipman

Dedication: photo by Eva Heyd

Pages 30–36, 38–42: photos by Eva Heyd

Page 37: photo by Jeff Machtig

Page 73: Beth Lipman, working at the Museum
of Glass, Tacoma, Washington, 2006.
Photo by Liz Lepance.

beth cavener stichter

Cover: photo by Noel Allum

Pages 44–47, 52–56: photos by Noel Allum

Pages 48–51: photo by Gene Young

Page 57: photo by John Carlano

Page 74: Beth Cavener Stichter molding belly of
J'ai Une Ame Solitare in her studio, 2003.
Photo courtesy of artist.

jocelyn châteauvert

Epigraph: photo by Mark Tade

Pages 58, 63–69: photos by Mark Tade

Page 60: photo by Peter Krumhart

Page 75: Jocelyn Châteauvert, working in
Charleston, South Carolina, 2006.
Photo by David Puls.

Page 31: Arthur C. Danto, *The Transfiguration
of the Commonplace*, (Cambridge, Mass:
Harvard University Press, 1981).

Pages 48–49: Flannery O' Connor, *Mystery
and Manners: Occasional Prose*, selected and
edited by Sally and Robert Fitzgerald (New
York: Farrar, Strans, and Giroux, 1969).

Quotations were taken from the authors'
interviews with the artists.

acknowledgments

The imagination and vision of many individuals came together to make the exhibition and accompanying catalogue, *From the Ground Up: Renwick Craft Invitational 2007*, a rewarding project. We congratulate the four artists—Paula Bartron, Beth Lipman, Beth Cavener Stichter, and Jocelyn Châteauvert—for their sustained commitment to their craft. This exhibition is a tribute to their many years of hard work. In practical terms, I am grateful to them for their hospitality during my brief but intense studio visits and for their patience in responding to myriad questions on a tight exhibition schedule.

The artists' dedication is matched by the generosity of studio glass collectors Ryna and Melvin Cohen, who share with the artists an enthusiasm for craft. The Cohens' support now ensures that the Smithsonian American Art Museum leads the nation with a biennial exhibition series dedicated to the achievements of craft artists deserving of greater attention. It has been an inspiration and a privilege to work with the artists and the Cohens.

The selection of artists for the 2007 Invitational evolved from my collaboration and consultation with two esteemed colleagues: Susanne Frantz, independent curator and former curator of twentieth-century glass at the Corning Museum of Glass, and Lloyd Herman, founding

director of the Renwick Gallery. They shared their expertise and insights, and I thank them for their valuable contributions.

Many generous lenders willingly parted with significant works so they could be shared with the public. Their cooperation, as well as the assistance of galleries and institutions, ensured that the best works were available for this exhibition: Laurie and Charles Bails; Karen Johnson Boyd; Garth Clark, President, Mark Del Vecchio, Director, Osvaldo da Silva, Associate Director, Garth Clark Gallery, New York; Robin and Danny Greenspun; Bill Fick and Kristen Hondros; Doug and Katya Heller, Heller Gallery, New York; Stephen and Pamela Hootkin; Sharon Karmazin; Nancy and Philip Kotler; Nina Liu; Anna and Joe Mendel; Museum of Glass, Tacoma, Washington; Michael and Rose Peck; Dr. Charles H. Read and Chunghi Choo; Christine Rémy; Pat Sullivan and Jim Kolva; and other lenders who wish to remain anonymous. A special thanks goes to Marge Brown and Philip Kalodner for both lending works and providing support for photography.

A revitalized Invitational exhibition series would not have occurred without the support and guidance of Betsy Broun, the Margaret and Terry Stent Director of the Smithsonian American Art Museum.

The publications department adeptly crafted the Invitational exhibition into this handsome catalogue. Thanks are due to Theresa Slowik, Chief; Theresa Blackinton, Editor; and Jessica Hawkins, Designer, for their sustained and dedicated work. Several photographers contributed their talents, including Eugene Young, Chief Photographer, Smithsonian American Art Museum; Mark Tade, Gazette Commercial Photography; and John Carlano, Philadelphia.

Colleagues at the Renwick Gallery and SAAM provided a variety of support for this project, especially: Marie Elena Amatangelo, Exhibitions Coordinator; Jim Baxter, Exhibit Specialist; Fern Bleckner, Deputy Chief; Jeremiah Gallay, Exhibition Designer; Eileen Garcia, Renwick Gallery Intern; Laura Graziano, former Assistant Registrar, Exhibitions and Loans; Eleanor Harvey, Chief Curator; Marguerite Hergesheimer, Museum Specialist; Robyn Kennedy, Chief, Renwick Gallery; Melissa Kroning, Registrar; Jennifer Lindsay, Renwick Gallery Intern; Rebecca Robinson, Assistant to the Chief; Richard Sorensen, Photographic Rights and Reproductions; Kyra Swanson, former Exhibitions Assistant; and Jane Terrell, Registration Assistant.

Finally, I am grateful to my family, friends, and colleagues who read the essays and fueled my endless musings on craft.

JANE MILOSCH
Curator, Renwick Gallery